DRAW
ANIMATION

Paul Hardman

NEW HOLLAND

First published in 2007 by New Holland Publishers (UK) Ltd
London • Cape Town • Sydney • Auckland

Garfield House
86–88 Edgware Road
London W2 2EA
United Kingdom
www.newhollandpublishers.com

80 McKenzie Street
Cape Town 8001
South Africa

Level 1, Unit 4
14 Aquatic Drive
Frenchs Forest
NSW 2086
Australia

218 Lake Road
Northcote
Auckland
New Zealand

10 9 8 7 6 5 4 3 2 1

ISBN 978 1 84537 674 1

Senior Editor: Corinne Masciocchi
Designer: Adam Morris
Editorial Direction: Rosemary Wilkinson
Production: Hazel Kirkman

Reproduction by Pica Digital PTE Ltd, Singapore
Printed and bound by Times Offset, Malaysia

DRAW
AN...ON

Cumbria
County Council

Libraries, books and more . . .

Please return/renew this item by the last due date.
Library items may also be renewed by phone or
via our website.
www.cumbria.gov.uk/libraries

Cumbria Libraries
CLIC
Interactive Catalogue

Ask for a CLIC password

CONTENTS

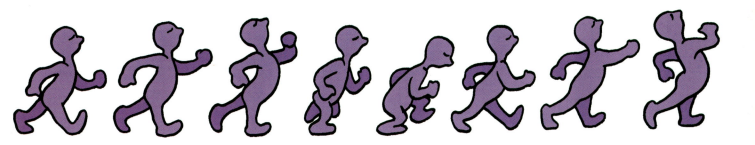

INTRODUCTION

Because you're reading this book, I'm sure you must already share some of the fascination held by all who work in animation; fascination for the magic of life that you're able to impart into a stack of inanimate, cartoon drawings. The thrill of seeing your drawings come to life for the very first time is something that will never leave you. Animation, the magical medium, can transport you to a land and time that is only restricted by your own imagination. Your characters can do the impossible and become the impossible in an instant. This is something that, until the recent advent of special computer effects, could never be achieved fully in live-action film.

The process of producing an animated film involves many varied skills and a great deal of time and dedication. I'll endeavour to take you step by step through a process which you will be able to achieve in your own home or studio. Because the set-up of a scene can often become very complicated I'll show you how to avoid these situations and provide you with solutions for a simple and effective way to produce a convincing end result that will, hopefully, prove both exciting and rewarding.

No production can start until a script has been written, with characters, backgrounds and props designed and a storyboard drawn up. I can't stress enough the importance of the planning stage before you start your project. During the course of this book we'll run through basic formats for writing, boarding, character design, layout, animation cycles and techniques.

Remember, you don't have to be a great artist to achieve great results in animation! Just follow some simple rules and... let your mind run riot! The wilder the designs, the more extreme the poses – the better the results!

You might have already read *Draw Cartoons* in this series and learned a few do's, don'ts and tricks of the trade from that book. Perhaps by now you have a couple of characters that you would like to see animated?

Well, let's get started... I hope you enjoy this book and enjoy the animation process... for enjoyment, alone, will be the secret of your success!

Paul Hadman

HOW AN ANIMATION FILM IS MADE

The main aim of constructing an animated film is to give the viewer an impression that it was all achieved by just one artist. In fact many hundreds of people can be involved over several years in the production of a major feature. There are many different skills required to produce any one film but the number of staff will be determined by the size of the project. Here is just a very basic idea, in flow-chart form, of some of the essential stages in the making of an animation film.

 First we have to start with a bright idea or an established story from a book. An idea with a good story line and strong characters.

 The idea is then translated into a full working script with scene descriptions and dialogue for the actors.

The Director takes the script to a studio to record the character voices. The actors are often recorded on their own with a video taken of their actions to help the animators with their poses and timing.

 Concept Artists begin to imagine the 'world' of this new script by drawing scenery, buildings, characters and props. Many ideas will be rejected before final approval.

Now the Storyboard Artist uses the script and approved designs to make an accurate comic book style visual of how the film will look.

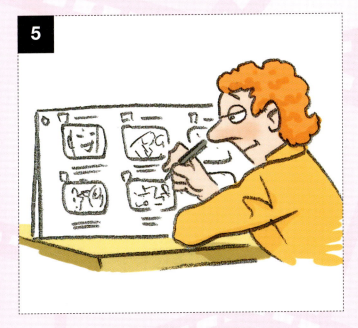

5

Exposure sheets are written. These show the animator and cameraman, frame by frame, how the animation should be drawn and shot.

6

The Layout Artist draws up the toolkit for each scene, showing the staging of each action, the type of background needed and the camera moves involved.

7

Animators and assistants rough out the movement of each character using the layout and exposure sheet instructions. These drawings are quite loose to capture the full flow of action.

8

Special Effects Artists also animate all other movement such as clouds, water and explosions. All animation is checked at this point by shooting the pencil work. This is called line testing. Any mistakes or improvements can then be addressed.

When the animation has been approved it goes to 'clean up'. Here, the rough animation is redrawn in crisp, accurate pencil line ready for the final shoot. The colouring-in happens in the next stage!

A final check is made and the approved artwork is then sent to 'digital colouring'. All characters and backgrounds are painted by computer nowadays, but occasionally some backgrounds are still hand painted.

A final check is also made on the coloured work before it goes to 'digital compositing'. This is where all the finished backgrounds and animation are put together to make the final scenes.

A musician will look at the rough-cut film and compose melodies for the sound track. Often, the music has to describe mood and the beats be synchronized with the action. This is achieved by recording the music whilst the film is being played.

Sound effects such as bangs and crashes are also added to the sound track. These can be recorded in the studio, taken from a 'library' of pre-recorded sounds or recorded especially from an outside source.

13

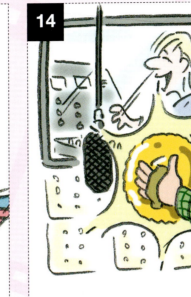

14

All the completed scenes, master sound track and sound effects are now cut together by the editor into the finished master tape or disc. From this master, many other copies are made for distribution around the world.

All the hard work has finally paid off! Now the finished film can be shown on TV or at the cinema. It can often take up to two or three years to complete all of this work for a major animation feature!

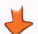

15

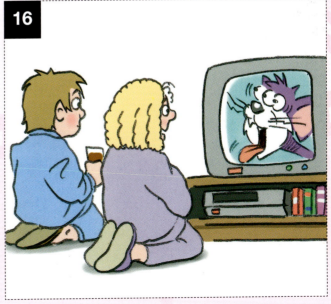

16

EQUIPMENT

The most important thing is that you enjoy your animation. Don't fall into the trap of spending a large amount of money on expensive equipment at the beginning. You can start with a simple sketch pad and pencil to develop a style and flow of drawing. If all goes well and you decide you want to progress, then here are a few essentials that you will need.

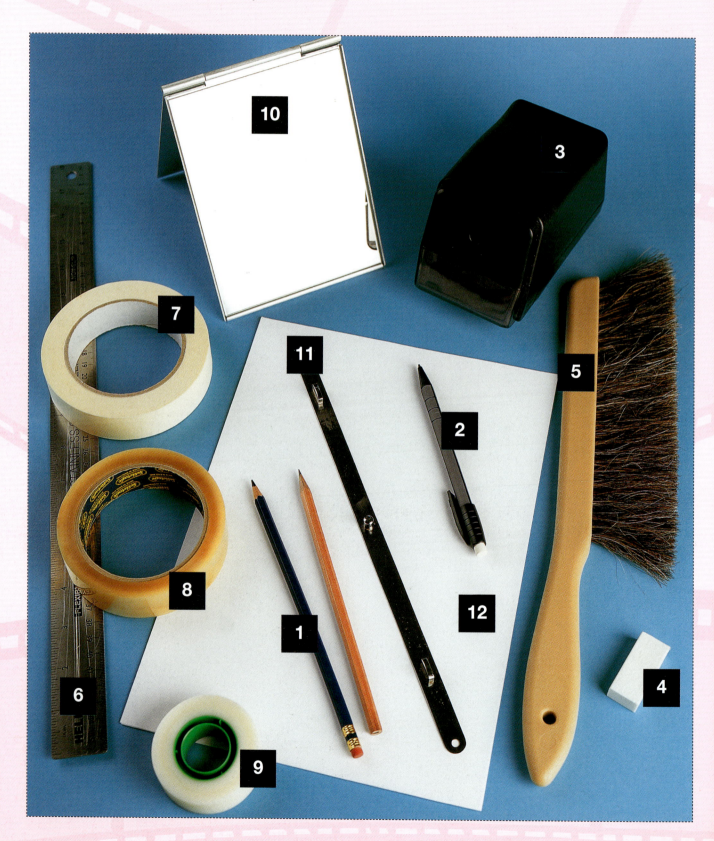

Basic equipment

Pencils On the whole, animators tend to favour softer pencils that will not break easily or cut up the paper. HB is the firmest for sharp lines although a 2B is often preferred. It's worth spending some time choosing a good make which will suit your style.

1 Blue pencil A soft blue is used to rough out the initial movement. This is often used by the animator for the first key drawings. Sometimes other colours such as red and green are also used in layout to denote special instructions or different layers.

2 Clutch pencil A favourite with animators, this pencil keeps the same fine width and doesn't have to be continuously sharpened. Most of a pencil can be lost to the sharpener rather than to the artwork when trying to keep the same sharp point!

3 Sharpener Because of the frequency needed to sharpen the pencil lead it's worthwhile investing in an electric sharpener.

4 Eraser This should be used as little as possible, but, in the beginning, will be necessary. Always have available a soft plastic and a putty rubber. The putty rubber is especially sensitive. It can be used either for complete erasure or for delicate 'rubbing back'. This leaves a line that can be cleaned up or worked on again. There is also an electric eraser, which is difficult to get hold of but a lifesaver on large, complicated works.

5 Brush Keep a soft-haired brush at the side of your desk at all times. This can be used to rid the paper of any carbon dust or eraser pieces that might damage your work.

6 Rule Always buy a metal rule – the longer the better! You will see later why this is an advantage. The metal rule is far less easily damaged and will also keep its graduations longer.

7 Masking tape Make sure you get a low adhesive tape which is not going to damage your paper. This is used for securing any background sheets or for taping down your peg bar.

8 Sticky tape This is always a necessary piece of equipment and will prove invaluable for all sorts of different tasks.

9 Magic tape A great way to join papers! The join becomes almost invisible and you can still draw over it. Excellent for backgrounds.

10 Mirror Have a small mirror handy for facial expressions. In an animation studio you may often see animators 'posing' in a mirror to catch the right sort of expression for their character.

11 The Acme peg bar This is used to hold your animation sheets in exact registration to each other. Start with the cheaper plastic model and always have two: one for the desk and one for the camera/scanner.

12 Paper Your paper should never be opaque. You will need to be able to see at least three of your drawings, one on top of another, at any one time. Tracing paper is too brittle and tears too easily. I would recommend a good layout pad for practice work. Once you are comfortable with your character and line you can proceed to animation paper. Here I would recommend you buy A4 (8½ x 11 in) economy pre-punched paper. This is paper that already has holes stamped in it to fit snugly onto your Acme peg bar. Animation paper usually comes in 'field sizes' – either 12 field or 15 field. However, an A4 size is now produced and this will be more suitable for most scanners, but more about that later!

Anglepoise lamp This is essential if you need more illumination on your work or to eliminate shadows.

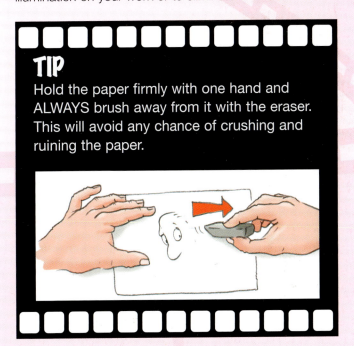

TIP
Hold the paper firmly with one hand and ALWAYS brush away from it with the eraser. This will avoid any chance of crushing and ruining the paper.

Now let's take a look at your work desk.

The light box

Buying a proper animation desk can prove expensive at the beginning. The one you see here is a portable version with variable height which is of simple construction and very popular with professionals. Let's run through the various elements of the light box to begin with and then, perhaps, we can show you how to build your own.

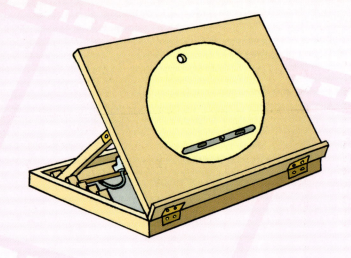

Animation disc

The very distinctive feature of an animation desk is the central glass or Perspex disc. This can be rotated smoothly to aid pencil control, avoid smudging and bring elements of the drawing to the hand more easily. This is essential when drawing controlled curves. The one shown here is of metal construction. Note the sliding, measured peg bars on the top and bottom of the disc. These are especially useful when constructing panning sequences. However, the disc is not absolutely essential at this stage and you can work quite well from a standard light box.

The standard light box

The fundamental element needed in all animation desks is a central area that is back-lit so that you can see clearly through the layers of drawings. The standard light box is a fixed wedge shape with an opaline, or semi-opaque, Perspex inset which is back-lit with a 'cold' light. This is a short fluorescent tube that will not over-heat the box. Another, often overlooked, essential is the bottom lip to catch pens and pencils. Your Acme peg bar is then taped to the base of the lit panel. The biggest disadvantage to this system is that you have no control over the board angle. I'll show you how to make a light box but first let's take a look at how to make your own peg bar. A standard double-hole punch used for filing papers can be used for your own animation sheets. Then, by taking a thin lathe of wood (the thinner the better) punch two holes 80 cm (31½ in) apart and insert two dowels no more than 1 cm (½ in) high into the holes. You must make sure, however, that these dowels are of the same diameter as the punched holes. This is usually about 5 mm (¼ in).

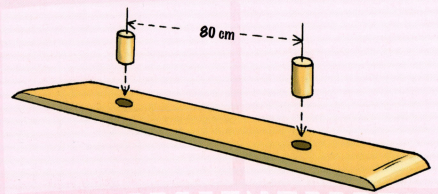

Making your own light box

You can find a number of sites on the internet that will supply you with instructions on how to make a light box but here I have some plans for you to make your own and save some money! The best construction material is 15-mm (½-in) thick MDF available from most DIY stores. You'll also need to purchase a small cold neon strip light – an 11-watt tube is quite sufficient for full illumination. Make sure that the strip comes with an external switch, which you can attach to the outside of the box as shown in the diagram. The central illuminated field consists of a 5-mm (¼-in) sheet of semi-opalescent Perspex. This is supported in the hole by 1 cm (⅜ in) beading which can also be used for the pencil catch at the bottom of the board. You will need a total of 185 cm (73 in) of beading.

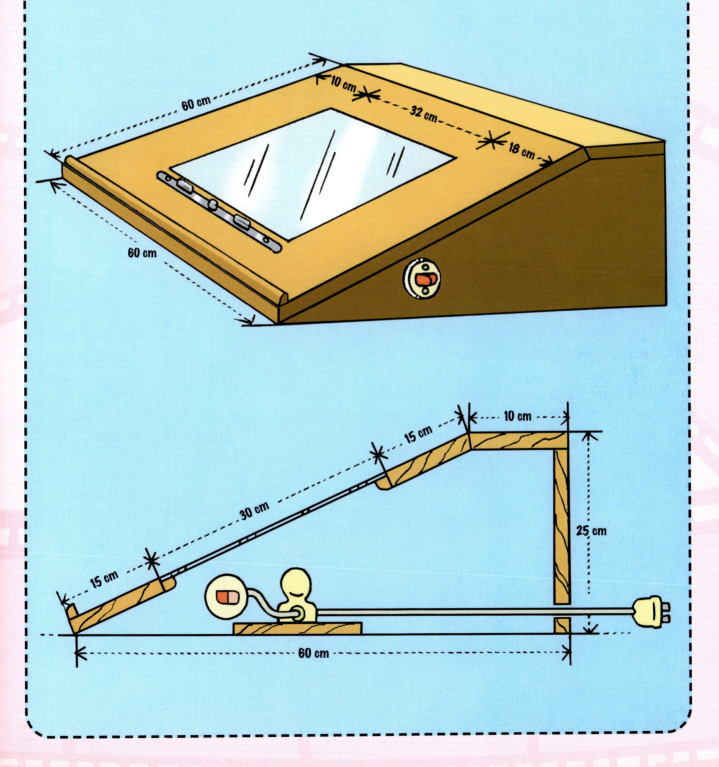

The camera rig

Here is a simplified illustration of the professional Oxberry animation camera rig. The camera is able to move up and down (truck in and out). Movement of the artwork from side to side (pan east to west or north to south) or turning (rotation), is done by moving the artwork table. Each of these movements can be done very precisely by turning one or more of the small wheels. The glass plate, or platen as it is called, presses down on the artwork to keep it perfectly smooth. The main point to notice is that it is very sturdy. The last thing any cameraman wants is for the camera to shake and shudder. When played back, this movement will be amplified on screen and ruin all the hard work done by the animators. When using this method of shooting there were always difficulties in keeping colours constant. As each new layer of cell was added it made the colour of the lower layers duller. Tricks were used to overcome this but, with the advent of the computer and video camera, most of these problems were successfully overcome. So now let's take a look at how you can set up your own camera rig. The page opposite shows a basic set-up. Remember the golden rule here: NO SHAKE. NO WOBBLE!!

The table top (1)

Make sure you have enough space on a flat, clean surface and that you tape or screw one of your peg bars to it. You should also have a sheet of clean, clear glass big enough to completely cover your artwork – you don't want to see edges of glass in your frame! If you want to pan your work at any time, then you can secure a metal metre rule to the table and 'slide' the peg bar along it. The disadvantage of this is that you can easily make mistakes with accurate registration. My tip would be to always tape your peg bar to the rule for each move of the pan. This is time consuming but pays off in the end.

The lights (2)

You will need to place an Anglepoise lamp at either side of the artwork – one lamp only will cast unsightly shadows and ruin the work. I would advise 100 kW daylight bulbs which will make the colours sharp and bright. These lamps will also have to be very tightly secured to your table top. Any wobble or turning of the light will give different light intensities for each frame and cause a flashing effect.

The camera rig (3)

This is where your own skills come into play. There has to be a very solid column fixed to the back of the table onto which you can clamp the video camera. The camera must not move when you press the record button. A camera with a cable trigger system would be ideal. Again, if you want to be able to truck the camera (move it up or down) on the column, then fix a rule to it. However, I would advise against it! Let's take things one step at a time and make sure the camera is sturdy first. So, once you have made sure the artwork is in focus your rig is ready for use.

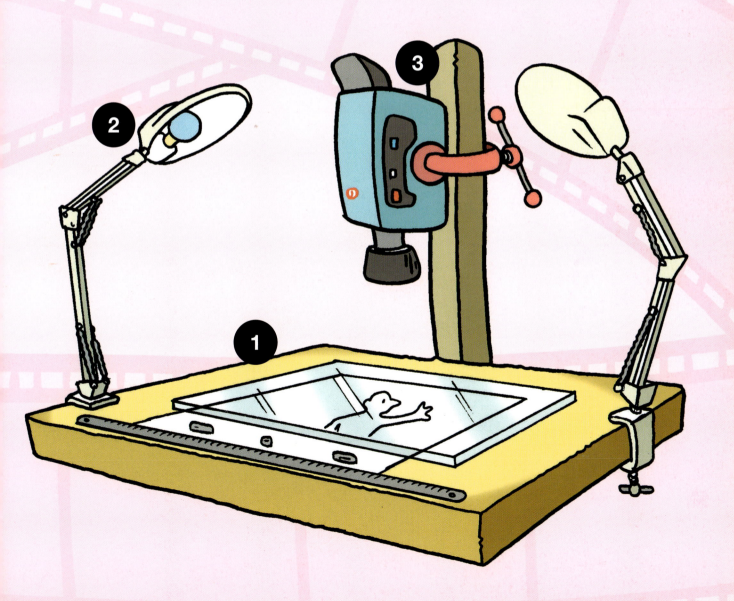

Using a PC and computer program

Most home-grown animation used to be shot with an 8-mm camera on single frame exposure. Whilst this was much easier and cheaper to run, it did rely on reel to reel film. You couldn't see the results until they came back from processing and any mistakes made meant throwing away the whole film and starting again. Nowadays we have digital cameras and computers to give us instant and editable results. Of course, you'll need an animation program to go with this system. There are several on the market and they're becoming more economical and efficient year by year. Some manufacturers supply a 'taster' pack which is much cheaper and well worth buying as a trial program before launching out to purchase the complete package.

The camcorder

We've already looked at the rig and seen the need for a firmly fixed camera. There is now a great choice of DVD cameras on the market. You'll need to find one that has the facility for single frame or photo-grab built in. If you're using the camera just for your line work, then perhaps a smaller, basic model would be more appropriate – something similar to that used for security surveillance. This camera will not record to tape but the images can be sent to your PC where they will be recorded and stored.

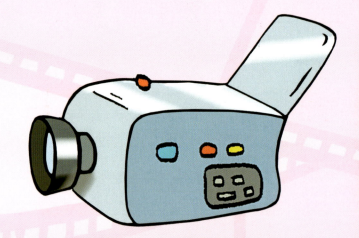

The scanner

An alternative to a camera can be a scanner. Make sure you choose one with an easily removable lid. This way you can tape your peg bar to the side of the scanner for registration, but keep that plate of glass handy to help press the paper down!

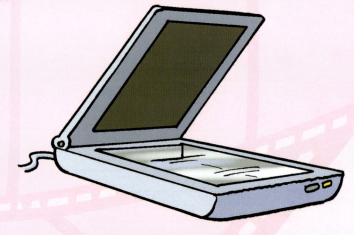

The tablet

It's well worth investing in a drawing tablet if you're using any form of graphics programme. The tablet and pen give you far more accuracy and variety than any mouse when colouring and drawing.

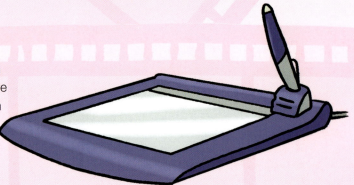

The PC

Most PCs now come with a large enough memory to cope with images for an animation film. Search the internet for good deals on animation programs to suit you and your pocket.

You can use your PC in two ways. First, you would check your animation with a 'line-test' and then, when satisfied, colour up and shoot the final film. The beauty of using the digital method is that you can mix, change, correct and edit to your heart's content without any loss at all of picture quality. Once completed, your film is still going to be 'locked' inside your computer. The one method of transfer to video would be to buy a piece of equipment called a Genlock. When connected between your PC and video player it will convert the computer signal into a video image. However, many computers now have CD and DVD burners included. I would advise this method of recording. The final film can easily be transferred to a DVD disk and played into your TV at home. A tip here would be to ALWAYS back up your work on CD or a removable hard disk. Imagine the heartache of seeing months of work being lost for ever through a computer crash or virus infection!

The rig

This is a typical set-up for your home camera rig. You'll notice I've included the camera and the scanner. You will, with practice, be able to determine which one of these suits you and whether you'll need a video player or not.

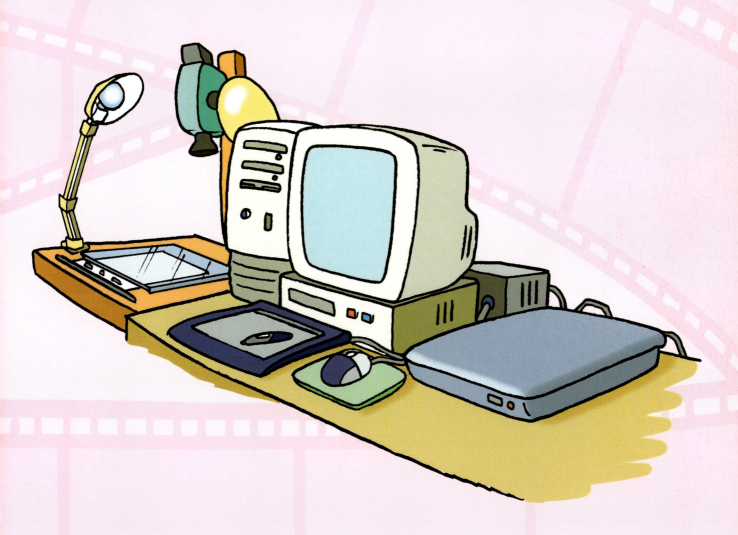

Now that we've had a look at all the equipment, let's see how you can organize your studio space.

GETTING STARTED

You'll probably be spending some considerable hours at your drawing desk. It's very important, therefore, to make this area as comfortable as possible. Your best work will always be achieved in a relaxed atmosphere. Choose a good chair and keep everything within easy reach so that you can concentrate fully on the task ahead!

Organizing your work space

The ideal set-up would be a quiet room or corner well away from the distractions of the rest of the home. The previous pages showed you the typical shooting rig but here is the drawing area and there are one or two things to point out.

It can be very easy to lose track of smaller items on such a workstation. This can be irritating but not devastating. However, the loss of just one frame of your animation can throw the whole project into utter confusion. I can't stress enough the importance of organizing your work space and keeping things in their places. You'll need to have the many pieces of paper sorted and kept together, IN ORDER, for each scene. I would recommend cheap paper files on which any information can be written easily. Can you spot all the pieces of equipment mentioned earlier on In the picture of the workstation on the opposite page?

You might notice a few additions. Perhaps the most important being the comfortable chair with good back support. You could be spending quite some time sitting in it! I would also recommend a 70–100 kW daylight bulb in the lamp.

Every artist usually develops a small library of books, which contain useful and essential pictures or text reference. This very book is one of them! So make sure there is a shelf available, which is well clear of your working area.

Now there's going to be paper; lots and lots of paper! So you'll need to have pigeon holes to organize these files. You'll especially have to take care of what has been shot and what hasn't. NEVER leave sheets lying around, but rather keep them in order and in their correct groups. Believe me, you'll thank me for this tip!

Well, we're almost ready to draw. So, don't be nervous! Get the drawing pad and pencils out and let's get started!

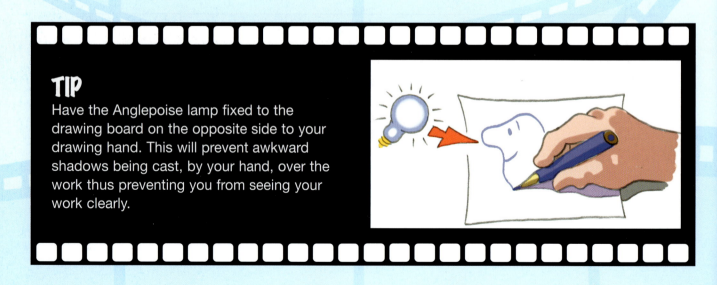

TIP

Have the Anglepoise lamp fixed to the drawing board on the opposite side to your drawing hand. This will prevent awkward shadows being cast, by your hand, over the work thus preventing you from seeing your work clearly.

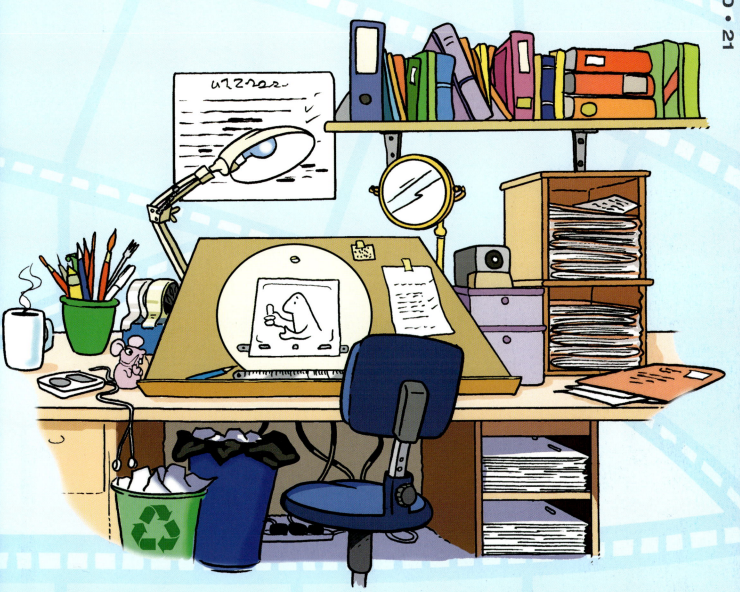

Let the pencil flow

Every artist will tell you!... There is nothing as frightening as the blank, white page! You'll rush to the paper, full of enthusiasm, see that blank white page and your mind will blank too! The next feeling will probably be fear. You won't want to commit pencil to paper at all and, when you do, you make small scratches that dig into the page. The thought will cross your mind: 'I'll never be able to do animation!'

Don't worry! Believe me when I say that this has happened to every single artist who ever took up a pen or pencil! The secret is to relax and enjoy! Don't try to animate from the start but rather take up one of your soft blue pencils and try some gentle flowing lines on the paper. Just let the pencil flow. You have probably experienced this already. Usually it has happened at school or at the end of a boring meeting. You get up to go and wonder, in amazement, where all those wonderful and complex 'doodles' on your pad have come from!

Action!

Often, on an animation film, the artist will regularly take time out to do speed sketching. This entails getting a subject to pose for just 30 seconds before changing to another pose. The artist has to get as much information down about the subject and 'feel' of the pose as he or she can in that short time. This is a wonderful way to free up the pencil and be forced to make bold, decisive strokes.

Why not buy a small pocket pad which you can take with you when you go out? A busy park would be an ideal spot to sit and observe. Try quick sketches of people bending to feed the ducks, children in the park or even the joggers! You won't have time to draw slowly as they move on or change poses. See if you can look at the way the body, as well as the face, can express emotion, now that you have a little more confidence.

Maybe a visit to the zoo or a safari park will give you lots of examples of action and weight. Weight is very important in animation as it determines how a shape moves and reacts to other forces. What is the difference between an elephant and a young child sitting? Do they run differently? It's always best to see an animal in the flesh but if you can't get to a zoo easily, then why not try sketching from natural history films or videos on the television?

Right! Enough of the scribbling! It's about time we got down to some basics of animation!

BASIC CONSTRUCTION

We are now going to look at different ways in which to build our characters. A good character will be able to convey its traits visually, well before it ever speaks a line of dialogue. If you're not using dialogue in your film, then it is especially important to show all character and emotion purely through the design of your character and the way it acts!

In the mood

A good animator must be a good actor and the secret to good acting lies in the mastery of facial and body expression. So, let's start with the face. This is where your mirror comes in handy (see pages 12–13). The mirror will be invaluable when you experiment with your own facial expressions!

The face contains more muscles than any other part of the body – and for good reason! Every animal needs to immediately recognize the mood of whoever he or she meets, friend or foe, for basic survival. The fundamentals of expression are governed by just three parts of the face:
- the eyes, which enlarge or close
- the eyebrows, which are raised or lowered in the middle.
- the mouth, which curves up or down.

Below are basic drawings with the three elements in combination. See how many expressions you can gain from the mix!

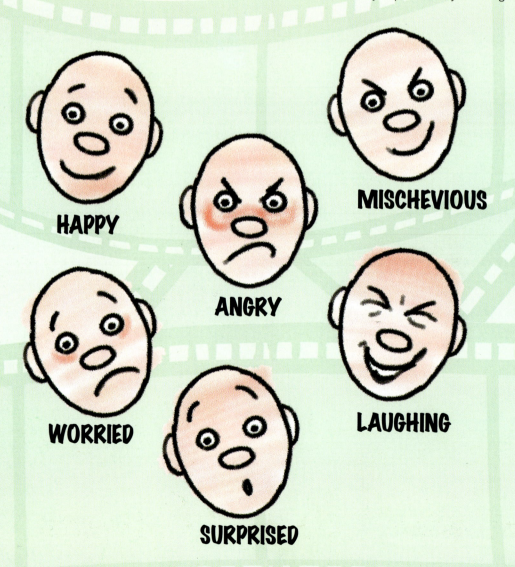

HAPPY

ANGRY

MISCHEVIOUS

WORRIED

LAUGHING

SURPRISED

With a little practice you can bring these elements into play in a character's face. We'll talk about character development later but have a look at this page to see how, with a little more 'acting', you can widen your vocabulary to cover almost every emotion possible. Here are a few quick sketches to illustrate some of these emotions.

Notice how even the ears, whiskers and mouth can be brought into play to enhance the expression. Combining all of these facial elements with body poses can really start to make your character come alive and develop traits of its own. Let's have a look now at how this is done.

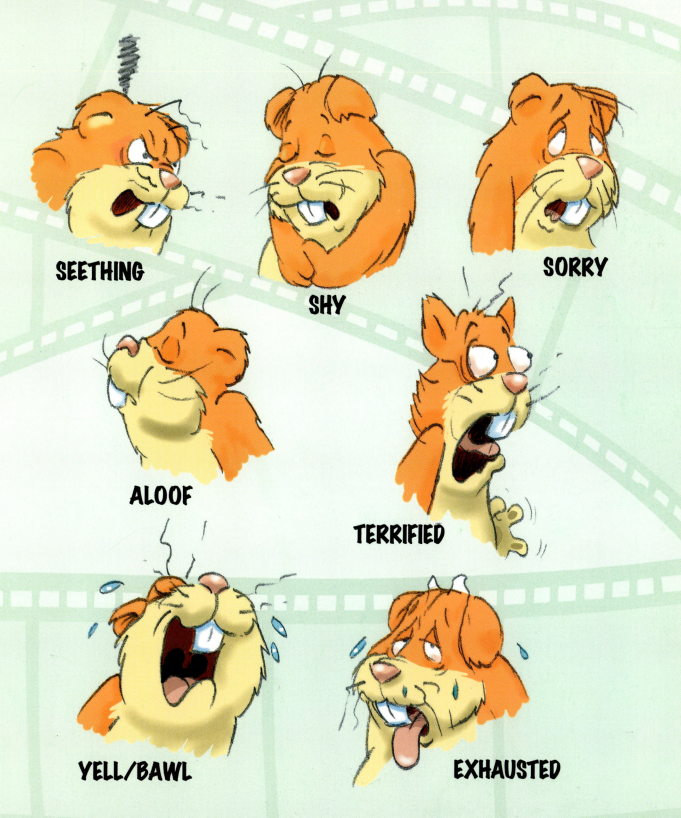

SEETHING

SHY

SORRY

ALOOF

TERRIFIED

YELL/BAWL

EXHAUSTED

Body building – boxes, beans and balloons

Before looking at how we can use the body form to show expression I think we should take a look at how animators construct bodies. Perhaps the two most important requirements for an animated character are that:

a) it will be able to walk, run and achieve all the movement required of it and,
b) that it will be able to be drawn in exactly the same way over and over again.

So, to aid us in our design, we'll use a combination of simple box and balloon shapes. Remember: although we're only drawing in two dimensions we must ALWAYS think in solid, three-dimensional form.

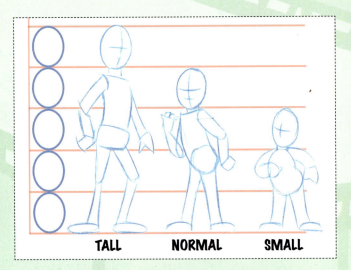

TALL NORMAL SMALL

Height We measure a character standing on two legs in 'head height'. Here are three 'human' examples of the tall, the normal and the child. You can see how, by stacking the head size in a vertical line, you can keep the height of your character constant. This will also help you to keep the comparison between two characters constant (see the example of the Comparison chart on page 37). As a general rule you can use five heads for tall, four heads for normal and three heads for small or child-like.

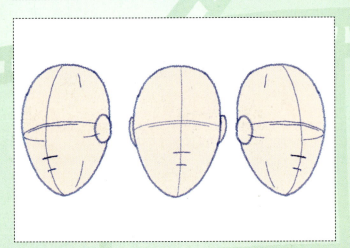

Body form Now we need to look at body types. There are no hard and fast rules about which shapes to use to build your body. The important thing is to be able to break the form down into simple shapes.

Notice here how I've drawn in a basic 'wire frame' to show the 3-D shape. You must use this at all times as a control guide to assist you when turning the character.

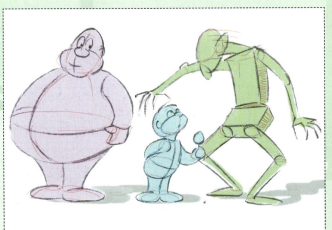

Here is an example of the basic head shape to show you what I mean. Can you see that, although the outer shape doesn't change at all, the central vertical line becomes essential in determining where the eyes, nose and mouth are going to be as the head turns?

We treat our animal characters in exactly the same way as the 'human' form. Very often we want our animals to look almost 'human'. Here is an example of using the same structure for both.

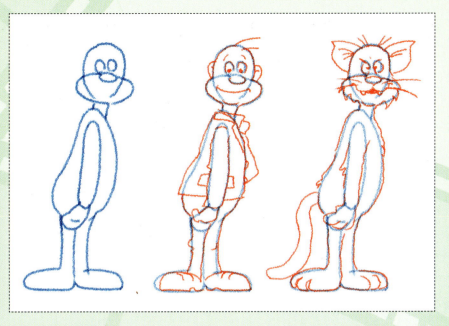

Not all our animal characters will be walking on two legs, however. Don't worry at this stage about making your characters too life-like. This can often restrict the 'fun' aspect of your final design. You can see from these examples that many of your balloon, block and bean constructions can be used for more than one animal.

Also, remember that your character has to be able to move and bend so be aware of this when building the frame. Can you see how it will be very difficult to make this rhino walk?

This is better!

Maybe you already have an idea in your head of what types of characters you need. Now is the time to experiment with different shapes and sizes and develop a powerful character that can act the part, so let's take a look at how the body can work for you.

Express yourself!

I've already mentioned that the body, as well as the face, can be very expressive and that this is all part of your ammunition for developing a strong personality. The cartoon character is a caricature of real life so you can err on the side of exaggeration to bring power to it. Remember, a good animator is a good actor, and your character needs to be able to express every emotion needed for your story. The wonderful advantage of animation is that you can do just about anything to and with your character. You can stretch it, squash it, slice it, dice it, fly it, blow it up and still it can live to fight another day! Let's have a look at some body emotions first. Below are just a few but, again, you can go out and about with your sketchbook and pencil to study people and animals expressing different emotions and see how they move, walk, talk and generally react.

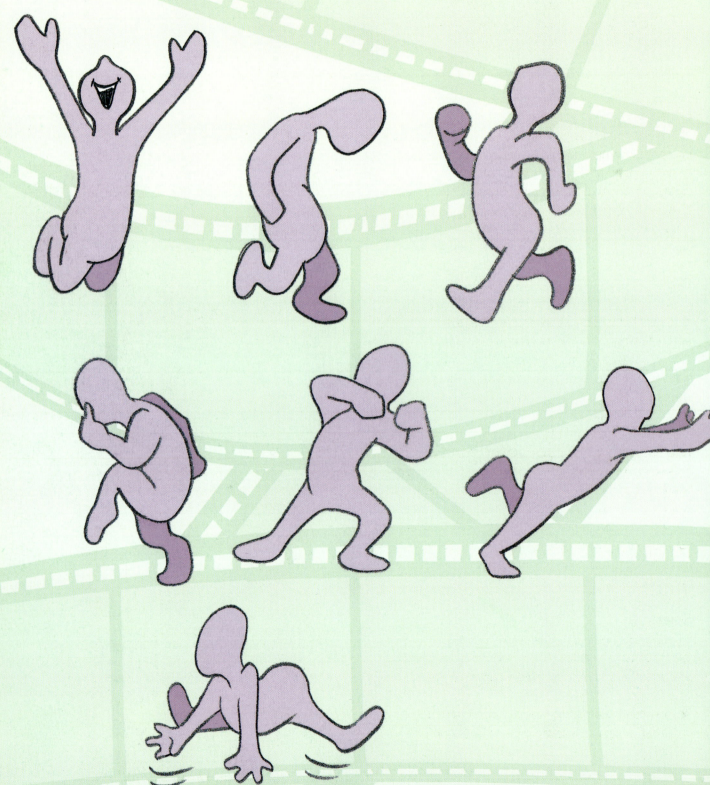

As I mentioned earlier, you can squeeze and stretch your character to exaggerate or enhance the emotion and bring in that extra humour that isn't possible with live action. Here are some examples that you'll be seeing later on.

Multiples

These are often used to cheat the eye into thinking that a rapid limb movement is occurring. It is, if you like, a way of squeezing more 'in-betweens' (see page 57) into a single frame. They don't have to be very accurate but should follow the line of action.

Stretch

This is used to fill the gap between two extreme poses in a fast movement so that the eye thinks there is a smooth action, otherwise the character might appear to jump or vanish between one position and the next. Line testing your work will always show you when this is needed.

Blur

Often used together with multiples to show fast movement. It was often painted onto cells as a dry brush effect. Nowadays, computer programmes can blur almost every frame in a fast action shot to mimic what happens in a live action still and produce a very realistic effect of smooth action.

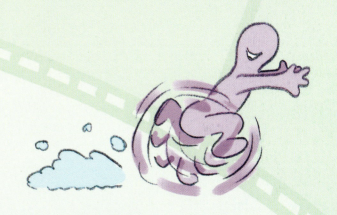

Distortion or false perspective

If you take a bird's eye view of your character, then the head will be much larger in proportion to the body as the legs become much shorter. If you look through a lens at someone reaching towards the camera, you will see their hand becoming much larger in relation to the rest of the body. In animation, we have to draw these effects to mimic live action.

Squash

We squash an object or character when it meets a solid surface, as in a collision. I'll come back to these effects later in the section on timing (see pages 76–81).

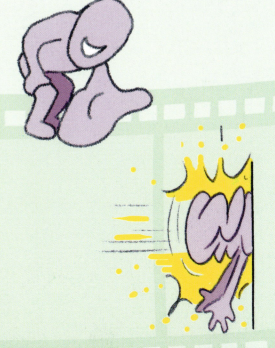

So now you have some of the tools and tricks of character design, let's take a look at character types.

CHARACTER DESIGN

It's well worth spending some time on the task of character design and getting to know how to build your character thoroughly before you start any animation. You can't afford to have a 'great idea' of how it should look half way through the film and you certainly need to know, from the very beginning, how to draw the character from any angle and in any pose without changing the look and feel of that character.

Type casting

I would advise that you only design your main characters after having laid out the plot of your storyline and can write down detailed descriptions of the main players. You should have a picture in your mind of what the character looks and acts like. Try to keep this stage as simple as possible. Lots of characters and complicated plots can overwhelm you with too much work. Here are a few ideas of classical character types.

 The hero: tall, strong brave and handsome.

 The heroine: elegant, beautiful and demure.

 The evil villain: tall, thin, hunched and ugly.

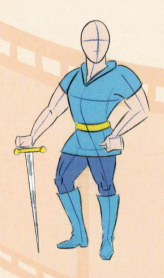

 The comedy act: often an animal or fantasy creature that is bumbling or neurotic. The one that's always getting into trouble!

 The servant or stooge: small, rotund and often dim.

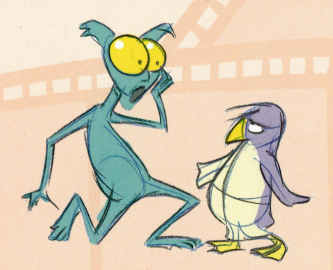

I'm not expecting you to include all of these types. In fact, for the first few films, it is advisable to use just one character and concentrate on techniques rather than story. Once you have established your 'model' you now have to look at costume.

We have to be careful when choosing a costume. Obviously this will depend very much on the storyline and in what period or 'world' you have set it. I suggest that you try to avoid anything that is long and flowing or hangs and waves. This makes for complicated animation and is best left to the professionals. No costume at all or a tight fitting suit is the safest option for now. Then all you have to do is concentrate on the animation of the character. When you feel more confident you can start to think about clothing!

 Animals make an excellent choice as you can get away with no costume at all!

 This type of costume demands animation separate to that of the character. Each part arrowed has a different timing to the other and that of the character! Something to avoid when starting out!

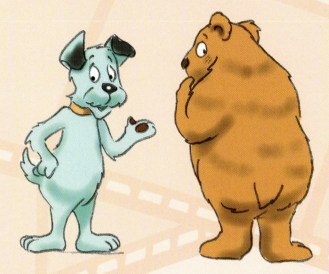

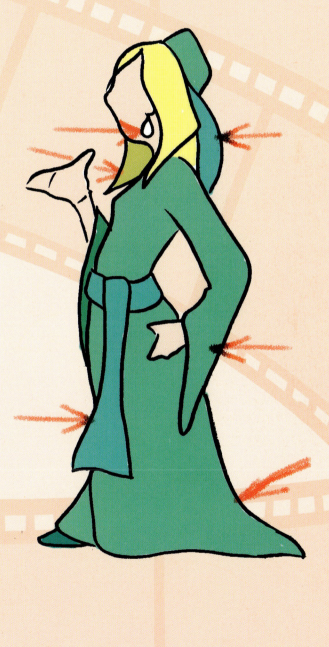

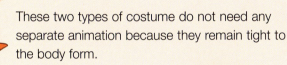 These two types of costume do not need any separate animation because they remain tight to the body form.

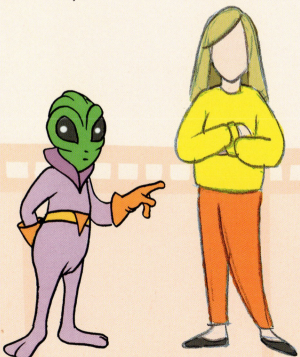

Now let's have a look at some examples of animal characters.

Choosing a pet

The best thing about choosing an animal as your character is that it can be much easier to exaggerate their most important characteristics. I would advise you pick an animal that already shows the traits of the character in your story. This way you will already be describing your character before you have even started to give it movement! You only have to look at the work of Disney and Warner Brothers to see how well this can be practised in the legendary forms of Mickey Mouse, Donald Duck and Bugs Bunny.

Here are some classic animal characters that already have well known traits that can easily be translated into visual form. Drawing a spiky dog collar on a bulldog emphasizes its pugnacity, just as adding half-moon spectacles to an owl creates an even greater sense of wisdom.

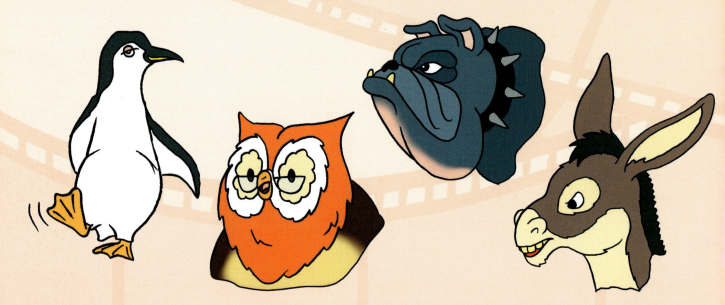

Remember I mentioned on page 27 that we can often use the same basic structure for more than one animal? Here I have put together a base structure using simple bean, balloon and sausage shapes to form an animal squatting on its hind legs. But look what happens when you start to change the ears and tails. Even with such small changes we get quite a number of different small mammal shapes from the one form.

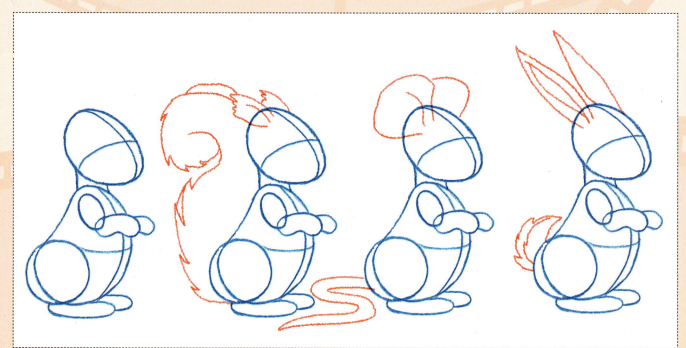

Ah, that's cute!

I now want to show you one of the secrets of animal design in animation. Often we want a comical and cute character. The best example of this in life is a baby or toddler! Here are the shapes used for a baby.

Large head and forehead

Big eyes low on the face

Small mouth and nose

Short stubby limbs and digits

Bean shaped body with bottom pushed out

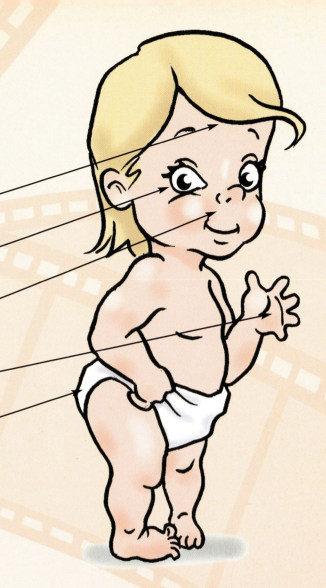

So let's translate those characteristics over to our examples. If I take a dog form and give it a large head and small body with the eyes and mouth in the same proportions to the baby above, you immediately get a young playful looking puppy! See! Instant cuteness and comedy!

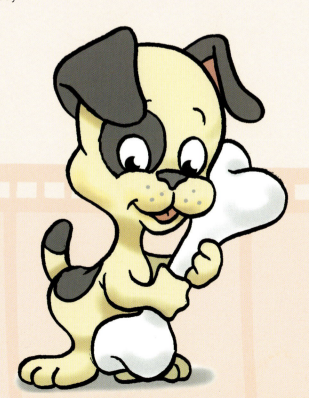

We'll now take a look at the one part of the body that often causes the most problems when drawing: Hands!

Give him a big hand! Or not!

Drawing hands often frightens even the most skilled of artists, yet the hand is one of the most important tools of expression we have in animation. The problem comes with the five digits – that always seems to be one too many when you're drawing! So the early animators came up with the idea of three fingers and one thumb – much easier to draw and much more expressive, too! It was especially suitable for small paws! Remember when drawing hands to keep them as simple as possible. Don't make the mistake of adding too much detail.

Below are examples of some of the poses used for what is sometimes called the Disney hand. You can see this type of hand on Mickey and Minnie Mouse. These are some of the more common poses. If you look carefully you'll be able to see that the last two are cheats, what is called artistic licence. They give an impression of a handshake and interlocked fingers rather than accurate representations. Now let's take a look at how these hands may translate to other animals.

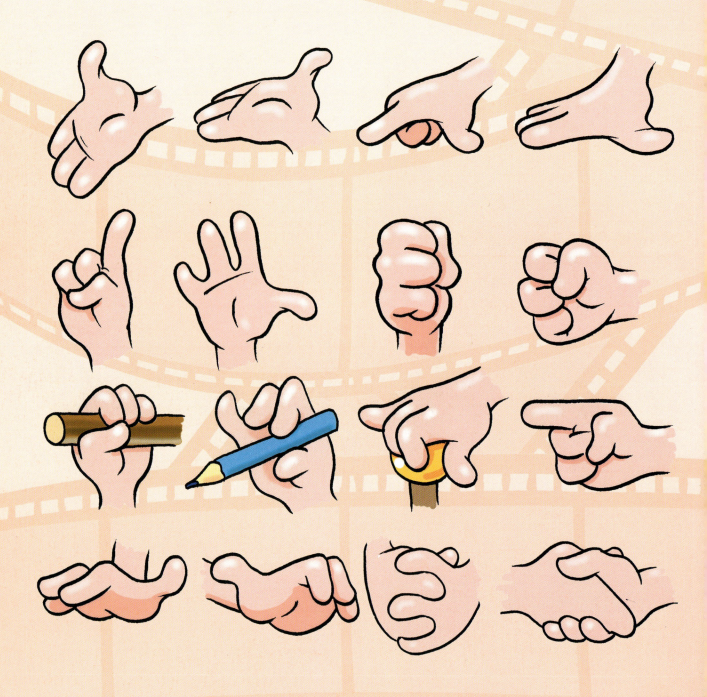

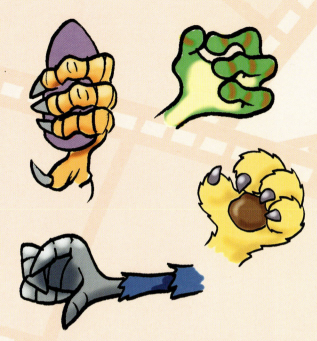

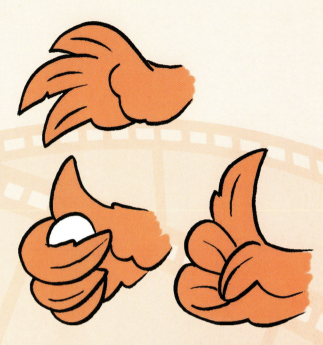

We tend to 'humanize' animal characters – especially in the hand department – because this solves so many problems of expression and handling props.

Now, birds are a little trickier. All the digits are in the upper part of the wing so we have to use the main flight feathers as fingers.

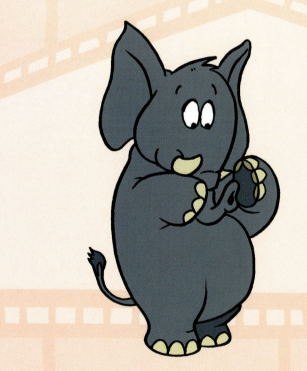

Of course there are certain animals it's very difficult to put hands on! Take a look at our elephant here. How on earth is he ever going to pick anything up?

Well, there's always some other way! – but make sure you never design or choose a character that isn't able to carry out all the actions you have written into the script.

So now you can collect all this information together and put it into a bible! A bible? Yes, a bible!

The bible – rotate, compare and model

After all this hard work you must collect and save it for future reference. Each character will have its own model sheet. A model sheet will contain all the reference you need to recreate each drawing accurately and without change – it is sometimes known as the 'bible' or 'blueprint' – in other words the instructions that MUST be adhered to. Here are some examples of what your model sheet should contain.

Construction: this section will show height in 'heads' and the frame in simplified shapes. The head measurement is literally the distance from the top of the head to the chin and has become the standard measurement of character height in all animation. Notice how the character is built up from the simple circle, bean and sausage shapes.

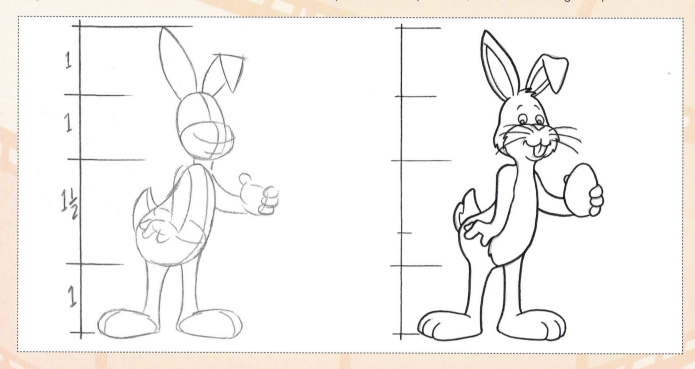

Rotation: sometimes called the turn-around, this strip should show your character from a front, three-quarters, profile and rear view. This is a turn of 180 degrees, however you might need to show a rotation of 360 degrees, if different objects or props appear on different sides.

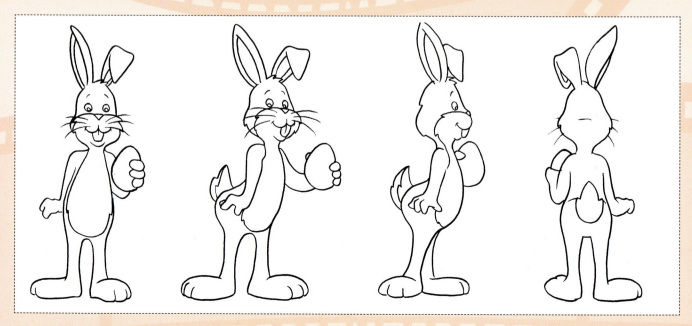

Poses: I've just shown four typical poses in this next example but they can often take over several pages in the bible. Can you see how the character designer has made a special note about the use of the left ear? Some sheets will also contain just facial expressions and mouth shapes which are used for the lip sync (see Glossary pages 92–94).

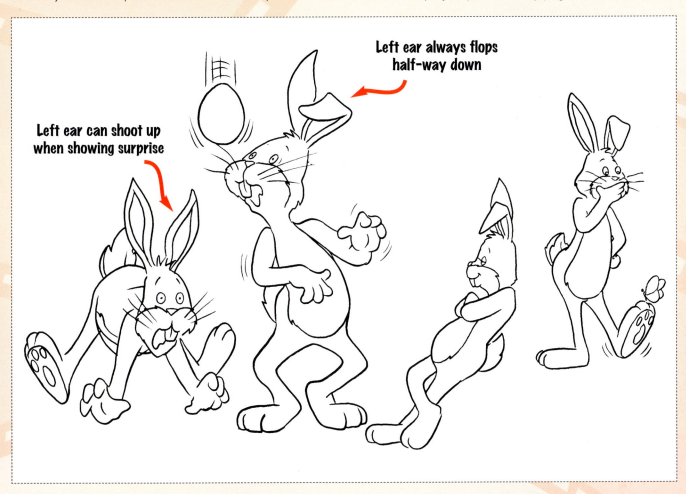

Size comparison chart: if you are using more than one character, then you will need to have some reference of comparison of sizes between these characters. The example here should be self-explanatory.

Colour spec: if you're filming in colour, then you must also make a record of every colour and where it is to be used on all characters and props. Either keep a colour master file on computer from which you can re-sample the colours or have a section in your bible where all the colours are shown and noted in RGB format, which is the colour type used for screen.

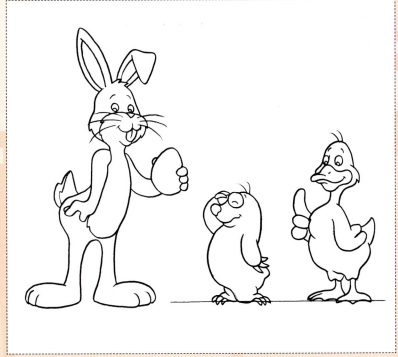

CREATING YOUR WORLD

Along with your characters, you need to be developing a world in which they'll act. My advice here would be to try to immerse yourself in this new world by doing lots of drawings – what we call concepts. Imagine the country, the climates and the architecture – even the furniture and props your characters will be using! The more you draw, the more the ideas will flow. I can guarantee that, if you take this advice, you'll shock yourself when you see the finished product. You'll sit back and say: 'Did I really create all of this?'

The plot thickens!

When starting out on an animation project it's very important that you do not try to be too ambitious. Give yourself a time span of, say, two minutes, or three at the most. Remember that at just twelve drawings a second, three minutes becomes 12 x 60 x 3 = 2,160 drawings! There are ways of cutting this down which we'll look at in the section on Timing (see pages 75–81).

I have purposely left out lip synchronization (better known as lip sync) from this book as it involves intricate analysis, complex animation and editing to get it right. Write a script with a narrated story or purely visual action. This will make life a lot easier for the production.

The other thing to consider when writing your script is that you don't get involved in complicated action. Always 'visualise' your story as you write it. Be aware of any problems you might cause yourself in shooting the plot. Visualising the plot is also very useful for the next stage of the process, which is the storyboard.

The story needs to be complete, in other words it needs to have a beginning, middle and end. This can often be quite tricky to complete within the two- or three-minute duration so start with a plan. Just put down important events that you want to happen under bullet points. Use Post-it notes or an editing programme on your computer so that you can edit, switch or change the order as you go along.

The beginning

When you're satisfied you have a good framework you can start writing.THINK VISUALLY! I can't stress this enough. You have to 'grab' your audience in the first few seconds so that you have their full attention and they WANT to see more. Here are a few tricks to grab your audience's attention!

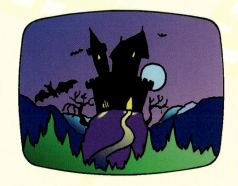

Strange opening scene or situation. The audience thinks 'what's happening here?'.

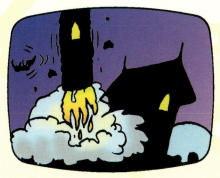

Dramatic fast event... an explosion perhaps? This wakes the audience up and gets their full attention!

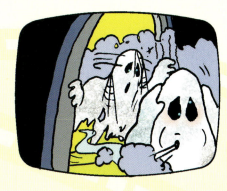

Start with visual comedy. This will make your audience laugh and let them know they are in for a ride!

The middle

For a short sequence you should also be describing the world, the characters and the situation that is to enfold. A great deal to get through! Then we move on to the middle. This is where the main body of the story enfolds. It can also be the most dangerous part, the point where you can 'lose' your audience. Have little flagpoles of action or humour at regular intervals to keep your audience expectant and on their toes! You might have heard of timing and pace in a story. This is something that you'll learn as you write. It's that something that makes a story flow. If your story feels awkward at any point, then find a way of changing the script to make it flow better. Always keep to the point and never get into action that is unnecessary or irrelevant. You'll have to sort this out at story stage otherwise you might be drawing many pictures that are not needed!

The end

Now you need to have a solution to the event you set up in the middle section. Again you need to enthral your audience so try to keep the solution to the last possible moment. This is often known as the 'cliff hanger'. Make sure you leave your audience applauding and demanding more!

Welcome to my world!

Once you have established the storyline and the characters you'll need to start designing a whole world in which they can live! Don't attempt to draw backgrounds at the beginning. Read over your script and try to visualize the surroundings you would like to have. Start with tiny rough sketches containing splashes of colour. These are called 'thumbnail concepts'. Here are a few examples. These can be completed very quickly and give you a very good idea of shapes and moods which the colour can convey. Obviously we can't cover every type of world within these two pages but the principles work for all situations. Just remember that your world has to fit the storyline, the mood, even the expectation of what is to come!

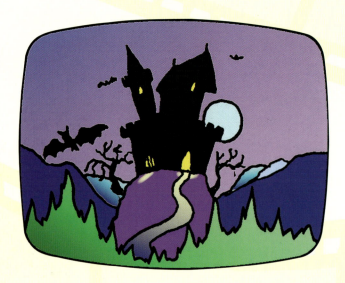

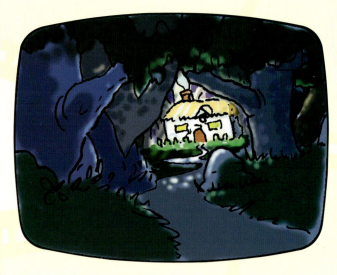

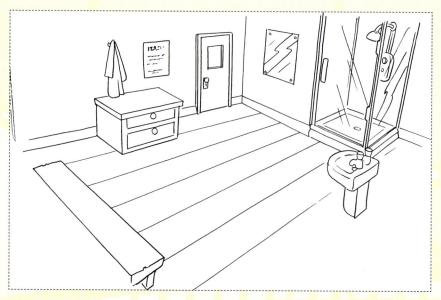

The next design job to address is the interiors of any homes or places where action may occur. Very often bird's eye views of these areas are draw as 3-D maps. This is a great help in remembering where things are when moving around the 'set'.

TIP

Remember to include any important props in these pictures. A prop is any object that your character will hold, move or interact with in any other way. You can see in this drawing how several props have been highlighted.

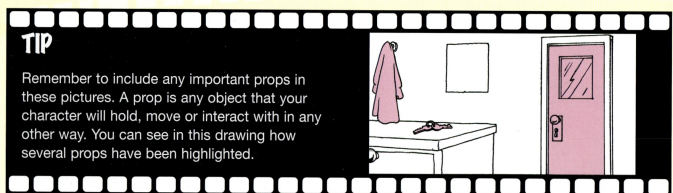

There are many things to consider when designing your world and that's why I've devoted several pages to background design. When starting out it's worth remembering to keep things simple. You have to remember that you don't want your world to be so complex, interesting and busy that your audience will not notice or be able to see your characters and what they are doing.

Here, your eye is being led off in too many directions away from the character who is trying to act. There is also barely any room left for him to act!

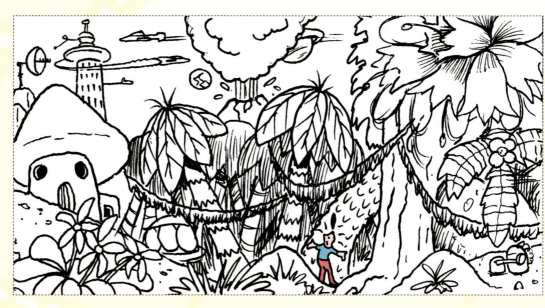

Design your world from the story. Situations and scenes will give you clues as to what you have to include. Only design what is going to be seen! This might seem very obvious but many a designer has got carried away with a larger plan, only to realize that hours of hard work and concentration have been in vain. Again, at this stage you are looking at concepts of what you want the world to be. The detail comes in the background design or build. Below are some artist's concepts for world designs.

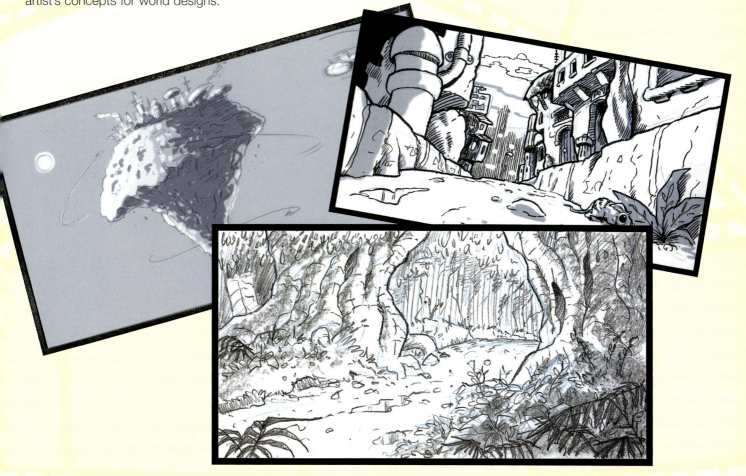

All propped up!

A prop is anything that will react with the character in your story. This can be part of the natural background or a man-made object. The reason they become so important in animation is that they have to be carefully designed so that they will interact properly with the character. We also want to make sure at an early stage that they are not locked into the background design as this will cause all sorts of restrictions. Here are two examples that can easily be forgotten when designing a background.

This rock should not be included in the background painting but should be on a separate level.

Again, the door will not be included on the background but animated to open on a separate level.

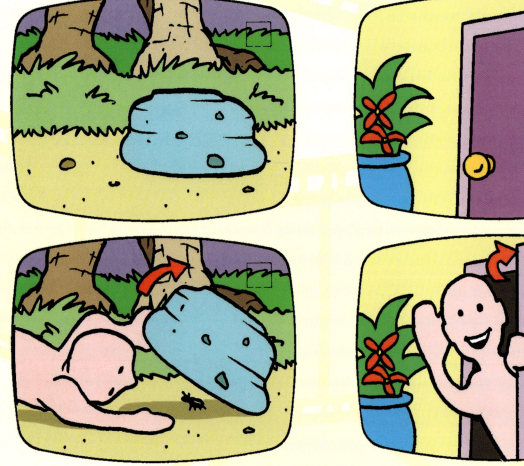

Earlier you will remember that we made up a model sheet for our characters. We do the very same for all our props.

TIP

I would advise that you have a reference sheet of all the props needed for a scene to be included in the scene file. In this way you're not scrabbling around heaps of paper to find the prop you need. This is what a typical props sheet would look like.

TITLE: STRANGER THAN FICTION
PROP SHEET
RAY GUN # 2
YARD BRUSH
OLD TREASURE MAP
GOLDFISH BOWL

You might find that during the course of your story development a prop takes on a character of its own. Suddenly it needs to have character and you find yourself putting eyes and a mouth on it. You have another character! This can prove very valuable in certain situations and can enhance the comedic or educative message you want to put across!

The next thing to consider is that your prop may need to include special effects (see pages 82–87). Here are a couple of examples.

A vehicle is often humanized to become a main character in the story telling.

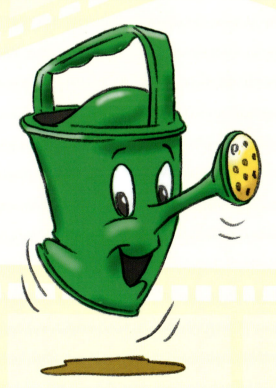

A utensil can react to, or interact with, your main character.

Again, be careful that you only bring in animation that you are able and want to handle. Any effects should be simple and on a cycle to minimize the amount of drawing.

Now we have the world, characters and props designed, it's time to draw up the storyboard.

The storyboard

The storyboard will be your blueprint and master plan for the final film. Nowadays the storyboard is constructed by the editor as if it were the final film. Each picture on the board is timed and edited into a final film length with rough sound effects and voices added. By using this method you can be sure that you know how much work is needed for each section or scene and, most importantly of all, you will not make the mistake of drawing one more sheet of animation than you need to. It could be heartbreaking if you've spent hours animating a section of action, which uses hundreds of drawings, only to find that it won't fit in!

With this most valuable tool you can go away and animate section by section. As you complete each section you then replace the storyboard sequence with completed animation. When every section or scene has been replaced you are left with the final film already edited and timed to perfection! You will be able to purchase storyboard pads from your animation suppliers. These include a row of frames with boxes below to include direction and dialogue.

TIP

At this point it's necessary to work out a system of labelling each scene and sheet. In this way you keep the sheets in good order and the system can then be carried over to your scene files when you begin to animate.

The best way to describe how a storyboard works is to show an example. Keep your story and animation much simpler than the example below at this stage – it can become more complex as your confidence and skills grow. Always think of your viewers and how they will be able to follow the story line. This is the stage where you really do need to plan each shot very carefully. Never presume your audience knows what is happening, or about to happen. If you show a character walking through a door, then you must also show him coming through that door from the other side and moving to the next piece of action, otherwise the sudden change of scene can lead to confusion and break 'the spell' you have created.

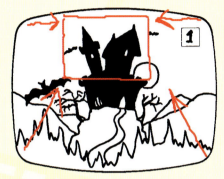

ESTABLISHING SHOT
SILHOUETTE OF CASTLE - NIGHT
SFX: CREEPY MUSIC SLOW
TRUCK-IN

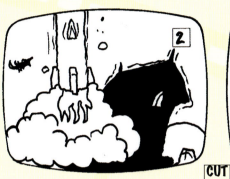

SFX: SUDDEN ROAR OF ENGINES
CAMERA SHAKE AS TOWER
BLASTS OFF

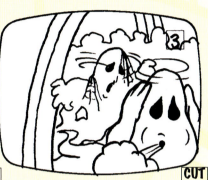

2-SHOT OF GHOSTS
STAGGERING FROM
DOORWAY, MOANING AND
BLOWING SMOKE

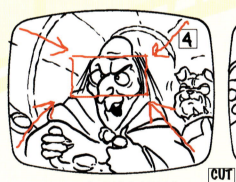

FROM 2-SHOT TRUCK
TO ECU OF EYES
G SAYS: 'FOOLS, THEY...'
SFX: ENGINES ROAR

2-SHOT G SAYS: 'DRONGLE,
GET THE...'
SFX: ENGINES

SFX: SPLUTTER, POP
G SAYS: 'WHAT THE...'
FX: CAMERA SHAKE

SFX: SPLUTTER
TOWER SLOWLY ROTATES THEN
ZIPS OUT OF FRAME SOUTH
SFX: DIVE BOMBER

FX: CAMERA SHAKE
SFX: DIVE BOMBER
HEADING FOR CASTLE
G SAYS: 'YOU FOOL DRONGO...'

Before we go on to look at background design, I think we should look at some of the things to do and to avoid when constructing your visual story on the boards. Do this now and there will be no tears later!

Some do's and don'ts

Composition: Good composition has balance, variety and makes use of both shape and space. Above all, it is pleasing to the eye, not allowing it to become confused or wander aimlessly around the frame or, worse still, shoot off and away from the main action. Here are a few basic diagrams of points to keep in mind when composing a shot. Below I've set out four basic diagrams to explain some of the ways of avoiding eye wander to keep your viewer interested. Remember, the information you present has to be direct and immediate, leaving the viewer fully understanding what is happening and keen to see more; even in the fastest of actions.

Make sure the action and interest are kept to centre screen. Anything that wanders off to the side will make the eye wander and could confuse the storyline. Also, try to avoid making anything in the background attract the eye away from the main action.

Avoid edges and especially corners. The only time this would be crossed is if a character moved into or out of shot. Professional animators and scene designers will always use a safety guide, similar to that above, to stop any wandering of important elements out of shot.

Give your shapes variety of size and flow of line. This flow of line is especially important in a pan shot for helping the eye to read the scene quickly. This is explained in more detail on page 54.

Make just as much use of spaces as with shapes. Here I am using the same diagram but now showing the space in black. Space can be just as dramatic as objects themselves. I will explain this in more detail on pages 50–51.

Creative backgrounds and poses

Even though you're designing a scene with buildings or trees and mountains, you are also composing shapes. You have to please the eye and tell it immediately where to look! The best way to explain this is by showing you some examples. If you were to look across a scene of rolling hills and trees you would notice that colours pale with the atmosphere as they recede into the distance, whereas objects in the foreground retain their brightness. Along with perspective, we can put this to good use in our scene designs to add visual interest and depth to our background. So, let's have a look now at how we can put these principles into good practice.

Having regular shapes at regular intervals makes the composition boring and flat. It also allows the eye to 'run off' the frame at either side.

When sizes are varied and the shapes placed irregularly, we gain depth and variety. Take care with perspective, however, and trust your own eye for a pleasing arrangement.

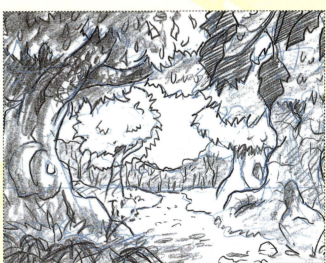

Notice that colour can also enhance this depth. If I stick with trees as our example, you will be able to see more clearly the differences as they occur and how they add three-dimensional depth to our scene.

The last frame shows an example of a thumbnail for a final design. Notice how 'space' has been created for the main action and how the trees frame and lead the eye back to this action.

Staging and framing

Unless you use the full space of the frame and think in three dimensions whilst animating your characters, then they also can make the scene look flat. Depending on what you need your characters to achieve, exaggeration produces a more dramatic or comedic effect. Different angles also make the action more dynamic and the viewer feel they are involved in the action rather than being a bystander looking in through an open window.

Here you can see that our characters make the scene look flat and uninteresting. They also seem a little stiff and don't appear to be reacting with each other very naturally.

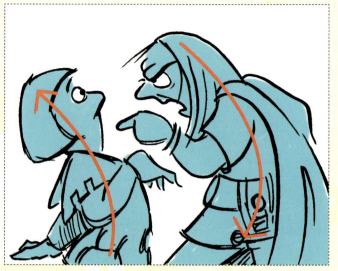

Interaction can be enhanced by using the shapes of bodies to show reaction. Remember, you must think as an actor does and don't be afraid to exaggerate your characters' reactions!

Dynamic compositions

These next two quick thumbnails illustrate how low or high camera angles make the shot more dynamic and, thus, more interesting. This is how you pull your viewer in and make him or her believe that they are part of the action. It's almost as if the action were being shot with a hand-held camera!

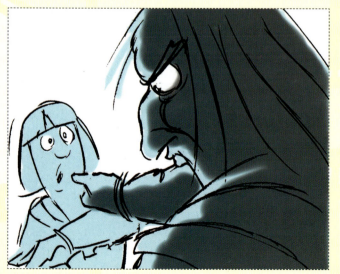

This is called an 'over the shoulder' shot. Here you feel as if you are almost 'spying' on someone else's argument. It enhances the fear of the weaker character as you peer down at them.

Here you become the weaker character as the aggressor bears down on you. This gives the viewer a feel of the fear experienced and makes the action much more exciting. This shot is called a 'point of view' or POV because you are looking at the action from one of the characters' point of view!

Positioning

The next two frames show a much more subtle rule to consider and that is of positioning. I've already dealt with forms of composition when dealing with more than one character, but what if the second character is off-screen? We can only see the character who is acting. At first glance you probably won't see much difference between the two frames – but look closer! Don't you just want to pull the first frame across to see who he is shouting at?

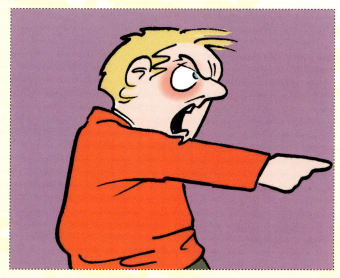 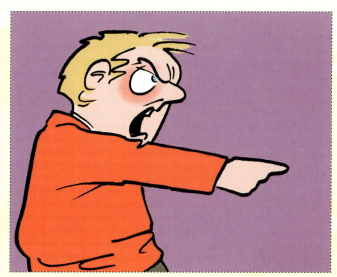

Remember that the action should be centralized. The question is – what is the action? Here we see a character who has been placed centre frame but the action looks awkward.

In fact, the centre of action is his face and mouth and he is shouting to someone out of shot on the right of him as we look at the frame, therefore we move him slightly to the left so that his face is centred. There! That's better!

Tangents

A very common fault when drawing is to produce touching lines called tangents. These flatten the artwork and confuse the eye. Remember that we're trying to convince our audience that our work is three dimensional, so tangents must be avoided at all costs. Here are some examples that explain this problem more clearly.

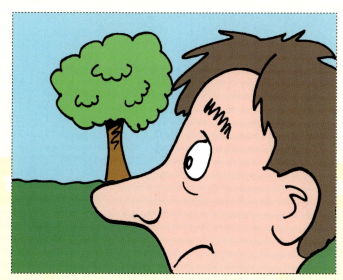 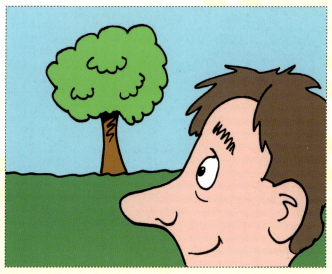

See here how the tree appears to be balanced on the character's nose and we lose all sense of proportion!

All is made good with a little repositioning and the depth of field restored.

Now let's take a look at our background design in a little more detail!

BACKGROUNDS

This is a subject that is often glossed over. The background should never dominate the action unless it is necessary for that 'Oooh!' factor. The real art in background design is to set the scene and mood and, most importantly, to direct the eye towards the action so that the viewer misses nothing of the story. The background design can be the difference between a bad or a great film!

Composing your background

I could devote a whole book to backgrounds alone. However, I will endeavour to point out some of the more important rules and guides to consider. Remember that your background can be as important as, if not more important sometimes than, your action. It is vital that the image you design is informative and tells your audience immediately where the scene is set and what the mood should be. The background should always complement the action and never dominate it. Wherever possible, the design should guide the eye to the action. Let's see some ways in which we can do this.

The field

Put simply, the field is the area in which you will be working. Most cameras and standard monitors work on a ratio of 4 x 3.

The wide screen format, which gives a more cinematic effect, is increasingly becoming more popular. The ratio you should use for this is 16 x 9.

The guide grid

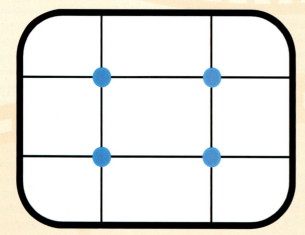

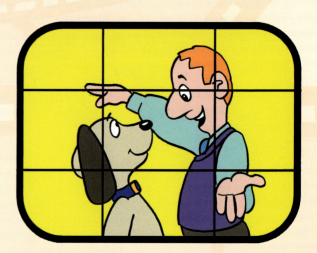

This is a simple grid of imaginary lines on which you should place the key images in your background. The four intersections shown as blue dots are the key points where you should place the action...

... you can balance the objects or characters at diagonal points like I've done in the drawing here.

Thumbnails

Remember I mentioned thumbnails (see page 40). These are very useful for deciding on camera angles and colours before committing to the final designs.

Depth

The background must appear to be three-dimensional. Always be aware of three levels in your design: the background, the middle ground and the foreground. I've coloured each of these to show them more clearly. The impression of depth can also be enhanced by the use of perspective and colour.

Negative and positive space

Positive space is where the action takes place. Negative space is that part of the background that frames the action or leads the eye to the action.

Here is an example of the negative space balancing the character's action.

Here we see how the negative space can guide the eye into the action. The bottom root is leading the eye in towards the point where the little character will pop out whilst the side root and tunnel walls stop the eye from wandering away from the centre of the frame. The whole background design, in fact, gives a spiralling effect which draws the observer into the tunnel.

But there are other ways of making the eye believe in depth – and that's by cheating!

Cheating the eye

Soft focus

Depth can also be achieved by having the background in soft focus. Only use this effect on close ups of your characters as this mimics how a camera would shoot the scene. Here is an example.

Forced perspective

Another way to mimic the camera is to use forced perspective in your background design. Here is an example of a character walking towards the camera, past it, then away from it. Can you see how we cheat the perspective? In live action, the perspective would be changing all the time but we can let the eye 'believe' this is happening in our two-dimensional drawing.

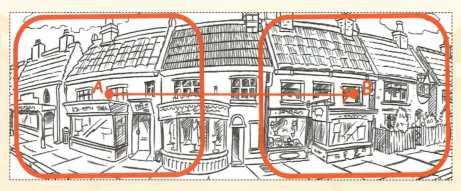

On the right is an example where the eye needs to travel from looking down to looking up.

There are three vanishing points, or VPs, to consider. At A we are looking down as in a bird's eye view so that the tower walls need to thin towards the first VP. Then, as our eye travels up the tower, the walls widen to their broadest girth at our eye-level, which is the second VP. Our eye then continues up to point B. Here the tower needs to be narrowing again but this time in the opposite direction towards the third and final VP at the tip of the flag pole. The same principles apply to all backgrounds where the eye has to travel up and down or from side to side.

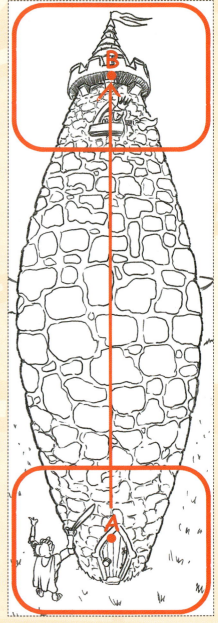

TIP

Try cutting a screen shape hole in a piece of card and holding it up to your eye. See what happens to the perspective as you turn slowly.

The tilted pan

This is used for various situations. Because we can only pan horizontally or vertically, we are severely limited – or are we? What if you wanted to have a character in your film skiing down a snow slope?

Can you see that this calls for a diagonal pan? How can you do this? Here's how! Can you see how all the background verticals have been drawn on a tilt? The camera is turned on a tilt to make them appear vertical and you can now pan horizontally in the normal way. Magic!

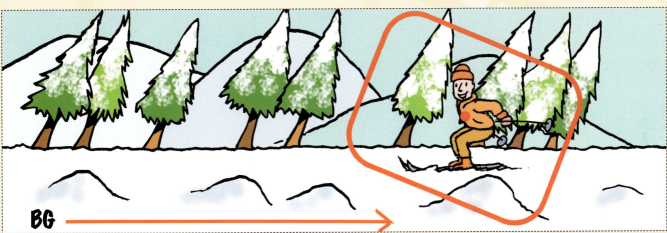

BG

Here is another simple but effective cheat. Let's imagine we have a close-up of two aliens in a craft flying through space. By cutting out the windows to show the background stars and planets you can, by moving your background slowly from north to south, give the effect of them flying through space. This is called the vertical pan. Try to find examples of all these effects in animation films you watch.

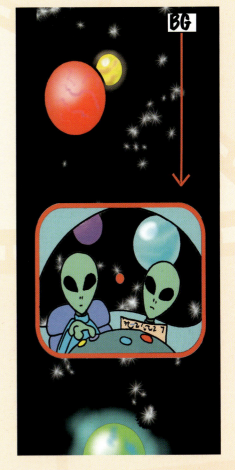

BG

Now, before we move on to the principles of animation itself, let me show you a few more points to consider when designing your backgrounds.

Pan handling

Strobing

This is an effect you will need to avoid at all costs when designing your pan background. The best way to explain this is to give you an example. Apart from looking uninteresting, when panning past these fence posts and trees you'll get an animation effect that, at best, will give them the appearance of moving in the opposite direction and, at worst, a nasty flashing sensation to the eye. This is because they are of similar shape and placed at regular intervals. The same effect can occur with railings or flagpoles. Avoiding this will make the background far more interesting and stop the problem. Vary the size, shape and distances as in the second drawing.

Flow of eye-line

If the background is moving fairly quickly you don't want it to invade the action or distract from your character with any jarring movements. Be conscious of giving a flow to the objects in your design as in this example.

Repeat pans

This is used when you want the pan to run indefinitely – for instance when a car is travelling along a road. To achieve this effect you will need at least two backgrounds, **A** and **B**. They must be able to be joined, at both ends, to each other without the joins being observed. Care must be taken to design each edge of **A** to fit each edge of **B**.

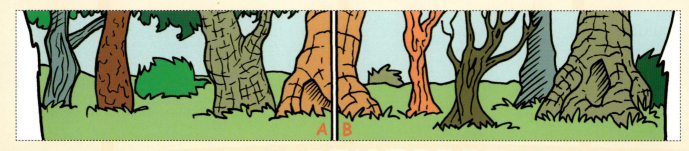

Layering

I mentioned the need for a three-dimensional effect earlier. Another way of tricking the eye into believing your world is three-dimensional is to have your character moving through rather than over the background. Let's take the example of the forest again. Here is the standard forest with our character walking along the path.

Now let's put another layer of tree trunks in the foreground.

When laid over the action, this pan makes us believe that the character is walking through rather than in front of the woods. Even more depth can be achieved by giving the back layer a softer focus, as mentioned on page 52.

Speed of pan backgrounds

It might be useful at this stage to take a look at a film in which a character is walking in between objects. You will notice that objects in the foreground move across the screen much faster than objects in the middle ground, whereas objects such as mountains or clouds in the far distance, will hardly move at all. You can have fun experimenting with speeds for your backgrounds. Your computer programme will allow you to build a scene using layers. In this exploded example you can see how layer **A** will move slowly as the character is moved up and down to simulate walking. Level **B** will move in the same direction as **A** but at a slightly faster speed.

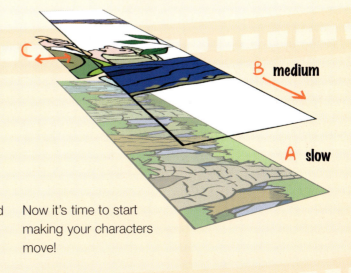

Now it's time to start making your characters move!

ANIMATION

Now we get down to the real work of making our characters come to life! The art of animation has, over the years, become a complex and exacting science. I cannot, nor would I attempt to, show you all the techniques within these next few pages. My aim here is to give you a glimpse at some of the basics and, hopefully, whet your appetite sufficiently for you to go on to perfect and continually improve your animation art.

Rough keys and in betweens

There are several ways of animating your character but I strongly recommend the one called 'pose to pose', which is the traditional method. When beginning to animate, take small scene-sections of one second or two at a time. Hopefully you will have edited your storyboard so that each scene only lasts a few seconds anyway as this will give your story pace. We'll look at pace in more detail in the section on timing. You must start with some idea of the time needed for the action you're about to animate. Keep the scene in your head and keep repeating the action over and over. Remember: you are the ACTOR for your character and this is your REHEARSAL! So, what do I mean by pose to pose?

2 1 3

Extreme poses

To begin with, you'll need to break down your character's action into 'extreme poses'. These are the final and exaggerated poses that your character is to achieve during the performance. Let me show you an example to better illustrate this idea. Here you have the character seeing a flower, picking it up, then smelling it. I haven't got the beginning or end poses of the animation but only the 'extreme' poses I want to include in the action.

The character still has to get into and out of this sequence, but more of that later. The three poses above will be the 'extreme key' poses I start with. Now I need to find 'in between' poses to show how the character will get from one extreme to the other. Now I have a series of drawings that will give me a good idea of how the action will look. These drawings should be done with the blue pencil and have a freedom of movement and line. They are not to be the finished artwork! Hence the name rough keys!

TIP
You should practise flipping the drawings at this stage. Place the series of key drawings between the fingers of your non-drawing hand and use a gentle rotating movement of the wrist. When done properly, this gives a rough animated effect to your drawings and allows you to see if the action between drawings is smooth enough.

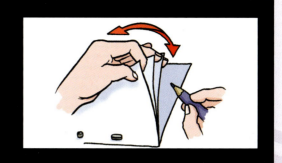

In betweens

In the studio, the rough keys are taken from the character animator by an assistant animator to 'in-between' and develop the action. A simple rule of thumb is that you draw a half-way drawing between each of the existing poses until you have built up a smooth set of actions. The more poses the slower the action, the fewer poses the faster the action. This will take some time to master but you can have great fun seeing the effect of 'more or less!'.

Line test it!

It's worth line testing your work as you go along. Here, you put the sequence of drawings into your computer to see how things are going. You'll be able to see if there are any blips or jumps and can repair them instantly.

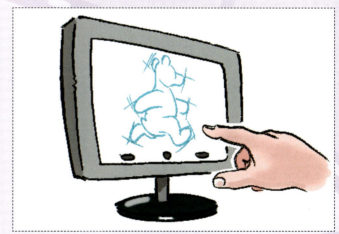

Clean-up

It's only when you are absolutely satisfied with the action that you then go to the clean-up stage. This is where you trace over the roughs to make the final, polished drawing that is to be included in your final film.

But before that, let's take a look at some basic sequences you can use...

Walk this way!

The walk is probably the hardest piece of animation you will have to tackle. There are so many styles of walk that have been developed over the years but I'm going to show you a basic cycle. A cycle is a series of drawings that can be repeated over and over again. You'll see cycles come up frequently in other sections of this book. The great advantage of a cycle is that you only need to draw for one second or so to get as many seconds of animation as you need! To illustrate the walk I'm going to use Harvey here. Say 'Hello!' Harvey.

The walk shown below is called a walk 'on the spot'. This is when the figure remains in the centre of the frame whilst the background moves. This cycle below is for 12 frames. Each of these frames is exposed twice to make a sequence of 24 frames – or one second of animation. I have included guide lines (in red). You can make your own and place them behind your drawings to help you achieve flow of action.

Can you see that one step lasts from drawing 1 to drawing 6 and that 1 and 6 are the opposite of each other. I have included 7 and 8 to show the progression. 7 is the opposite of 2, 8 is the opposite of 3 – and so it goes until you get to 12. There are several points I want you to notice in the walk.

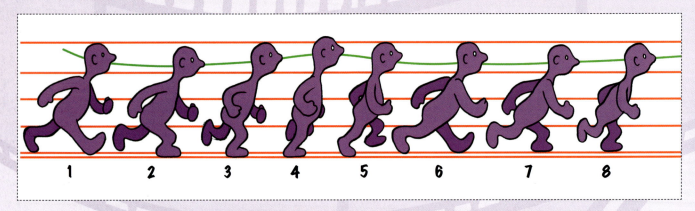

Stretch and squash

The first thing a student animator is asked to tackle is the bouncing ball! This shows you how we exaggerate the stretching and squashing in animation.

A very similar effect to the bouncing ball is brought into the walk. Harvey is squashed in drawing 2 and stretched in drawing 4.

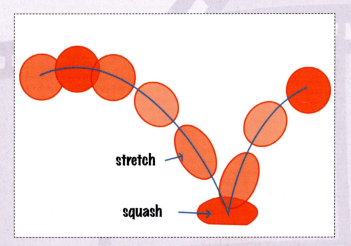

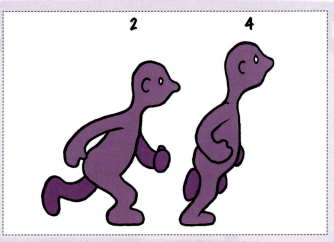

The head Notice how the head needs to follow a smooth line between each drawing as the green line shows.

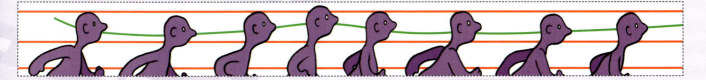

The hands These also need to move in a smooth arc, as shown by the blue line.

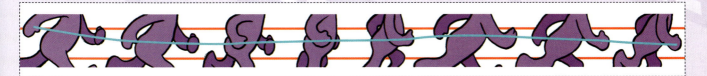

The feet Notice how the front foot comes down slightly lower than the back foot. This is another way of getting a three-dimensional feel into our two-dimensional drawings.

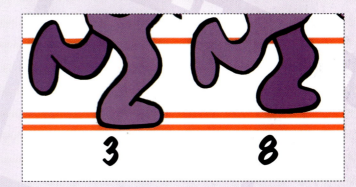

Once you've mastered the walk, you can go on to have some fun with more exaggerated poses. This cycle is called the strut. Can you see that it's basically the walk cycle with more extreme poses – especially in the stretch and squash drawings? Notice how the head is held back in a 'prouder' position.

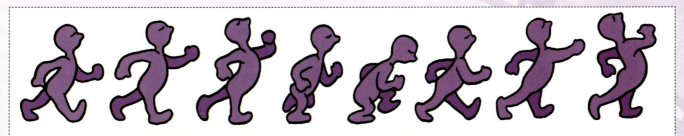

Remember when we talked earlier about getting emotion into the body shape? Here is another example where an opposite emotion is expressed. You hardly need to show any facial expression for this one!

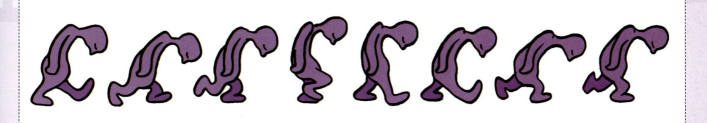

Well, we've looked briefly at the walk. Let's now see if we can enhance the action with some body movement! Are you ready to rock 'n' roll?

Let's twist, rock 'n' roll!

When you have mastered the walk cycle you might just be wondering if it doesn't look a little too... well, 'ordinary'! If you traced a walk from live-action film you would find that it would look rather boring! Just as we caricature faces in cartooning to suggest the character type, so must we caricature the movement in animation. I've mentioned several times how the body can describe your character and also his or her mood.

Let's get Harvey to show you how the body has to compensate weight-shift during the walk. We can best see how this happens from a front-on view.

You can see that in mid-stride (**A**) the red shoulder and pelvic lines are level with the floor but, as the knees pass (**B**) these lines tilt toward each other over the standing foot. Notice how, with the green line through the spine, the neck and torso bend to compensate for the weight.

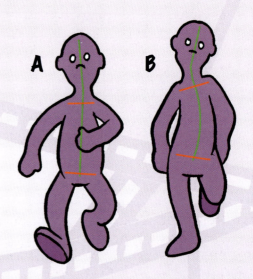

Rock 'n' roll

We can make use of this to a greater or lesser degree to describe our character. Watch now how Harvey goes through this half-cycle walk.

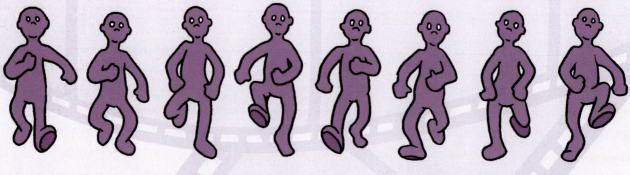

We can exaggerate the rock 'n' roll to give Harvey a very pompous air as he struts along. Remember the strut cycle I showed you on page 59? Well here are a couple of frames of that cycle as shown from the front to illustrate how Harvey rocks! Notice how the angles of the shoulders and hips now occur on A and not B.

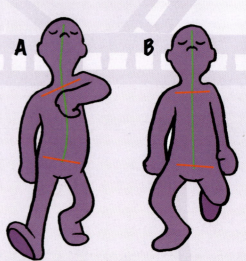

The twist

Here you can see how the torso is also twisting. In this frame you can see how the shoulders rotate towards the stepping foot as the pelvis rotates away from it. This whole action is then reversed as the other foot comes forward to step. So with a combination of twist, rock 'n' roll and extreme poses you can have fun developing your character.

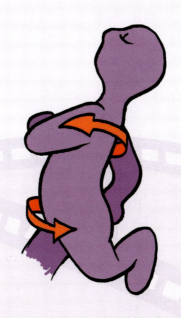

Weight

The heavier your character, the more exaggerated these movements become. Also, gravity can come into play here to give a comedic effect. I've fattened up Harvey to show how the stomach can be animated like a balloon full of water. Notice how it responds to gravity in the extreme poses. Also see how the squash and stretch is bigger to get over the mass of weight. Remember that this walk will be slower and will require more drawings.

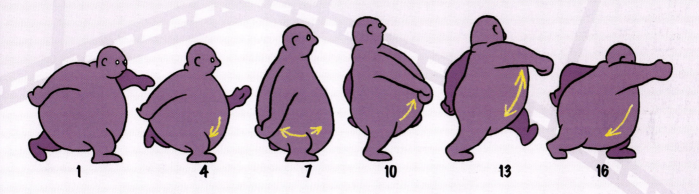

1 4 7 10 13 16

I think poor old Harvey needs to get on an immediate diet and take some vigorous exercise because the next thing we need him to do is run!

UH?

On the run!

We've had a look at the human walk, now here we have Harvey to show us the fast run. This only takes eight frames for the complete cycle. Remember I said earlier that the faster the action the fewer the frames or drawings, so take great care to check the flow of movement by flipping (see page 57).

In the next illustration I am not going to include the whole run cycle of 8 frames but just the first step. Can you see that frames 1 and 5 are the same pose but with opposite arms and feet? Other repeats would occur on frames 2 and 6, 3 and 7, and 8 and 4. As in frame 1, it's always best to start with the full stride. Can you see how Harvey is leaning into the direction of movement? Try this cycle for yourself. You might find that the timing is good but it may look a little too mechanical and jumpy. There are ways of avoiding this. The jumpiness is caused by the poses being far apart.

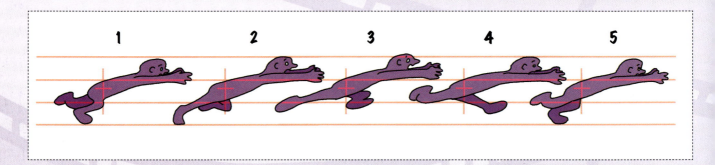

If you were to look at a live action example of running at the same speed you would notice the legs and feet would be blurred. So, try smoothing out your action by smudging, stretching or repeating. I've taken out frame 4 in the full cycle here to show you an example of smudging, or blur. Make sure, however, that the smudge follows carefully the line of action from the previous frame to avoid any obvious and unsightly jumps, so that the eye can see the continuity. Always check each small section of animation before moving on!

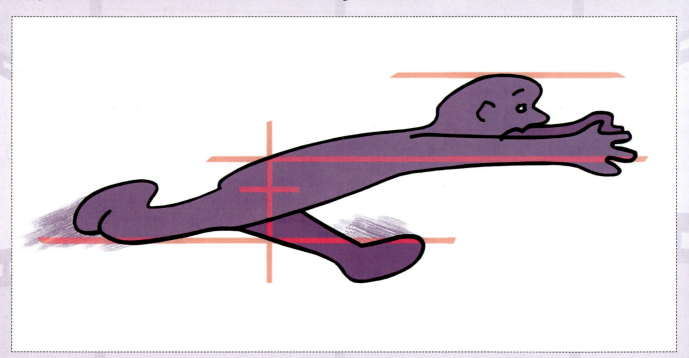

This, as it were, fills in the gaps between movements for the eye. You can have run cycles at different speeds. Another common one is the 12-frame cycle. Obviously, with more frames, the action becomes slower. You can even slow down to 16 frames but after this you begin to lose speed and it looks too leisurely.

I would advise that the up and down movement of the body be minimal for the fast run but more exaggerated for the slower 12-frame cycle as demonstrated by Harvey. Can you see how he has even leapt clear of the ground in the middle of this cycle? This is a case where the six-line grid, mentioned on page 58, can come in very useful.

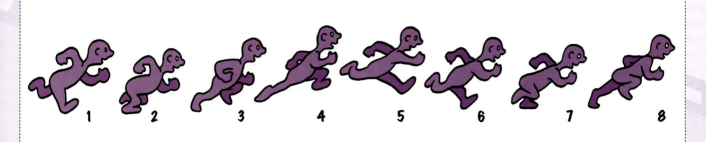

Slippage

One thing you must remember to take note of is the distance 'travelled' by the foot on the ground. Take a look at someone on a running machine in a gym, for instance. Even though we have Harvey running on the spot here, there has to be slippage of the foot on the ground. This is the distance Harvey is moving during each step (or frame in this case) and will be the distance 'x' that the background has to move each frame when the shot is put together. If you don't get these two distances exactly the same, then your character will appear to 'skate' or slide along. This rule applies to all forms of walk and run cycles. This is probably the most common fault – even in professional animation. Next time you take a look at an animation short, watch out for the 'skating'!

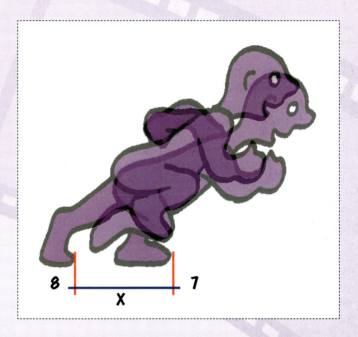

TIP

Photocopy a strip of measuring tape and paste it to the bottom of your animation sheets so that you can move them accurately between shots.

We've had a look at the human walk and run cycles but what about our animal friends? Are there any differences? Well, there are four legs to contend with for a start!

Animal antics!

The walk

I don't want to confuse you with the more complex movements shown in, say, a horse's legs and head during a walk cycle. Maybe Harvey can help us here. We could morph him into the shape of, let's see, a dog! Are you OK there Harvey?

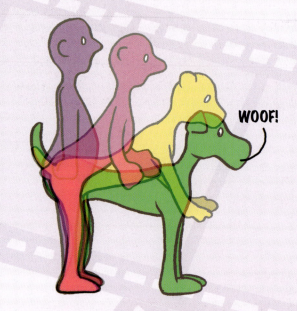

WOOF!

The simplest way of showing the four-legged walk is to treat it as if it were two humans walking, one behind the other. Imagine two men dressed up as a pantomime cow and you'll get the idea!

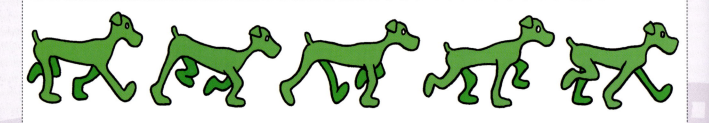

The above is not only simpler but more comedic. You might recognize it as the walk of Pluto the dog from the Disney films. So off you go Harvey! If you look separately at each set of legs you'll see that they are following the human walk cycle. Now look at the sets together in frame 3. Can you see that the back set are in 'stride' position as the front set are in 'passing' position?

TIP

Don't forget the difference in foot levels. The legs on the far side of the body are further away and therefore slightly shorter.

The run

I'll now get Harvey to show you the run sequence. This is very different from the human run. Here all four feet have to leave the ground at one point and the action becomes a bound or gallop. Here's Harvey to show you. You'll notice that I've now given Harvey a longer tail and you can see how that moves in relation to the body and legs, but I'll deal with this in more detail in the later chapter on timing and follow through.

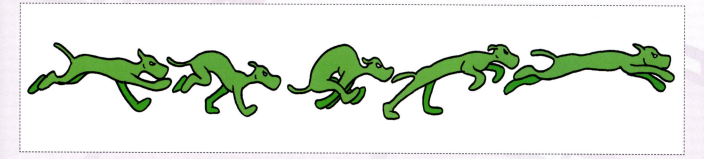

Here's the sequence from the front to give you a better idea of how the body and head move.

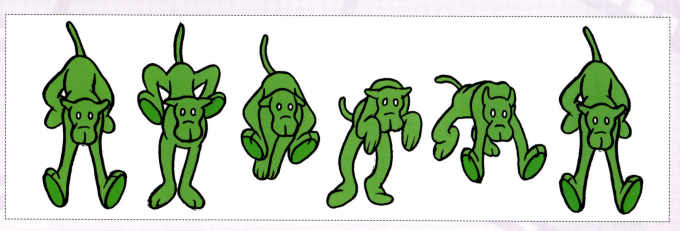

I suppose I can't move on without showing the cat's run sequence. This is the correct and realistic sequence which I don't expect you to follow but I always think this is the most graceful of movements. I've indicated here the numbers of each key drawing to give you an idea just how many in-betweens are needed for the full sequence.

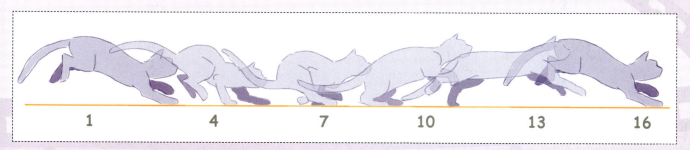

There is, of course, another option for your run cycle, which was made popular by Warner Bros. animation studios. It is the spinning wheel effect using blur and multiples that I showed you on page 29.

But more about that later!

It doesn't matter how well your character walks or runs if the rest of the body is not reacting in some way. The animator's job is to create the impression of a three-dimensional, living and breathing being. In the next two pages I want to show you two details of animation that are quite simple but will add tremendously to that feeling of reality in your character's movement. The first of these involves the eyes.

The blink

We all blink continuously. It's the way we're able to keep our very precious eyes clear and moist! In animation the blink is valuable in keeping the face animated without a massive amount of drawing. This cycle is as short as that of the run and once drawn can be repeated ad infinitum. Take a look at the following sequence. Can you see how the movements are closer together at the start and at the finish? This is because all movement takes time to gain momentum and time to come to a halt. I'll talk more about this in the section on timing.

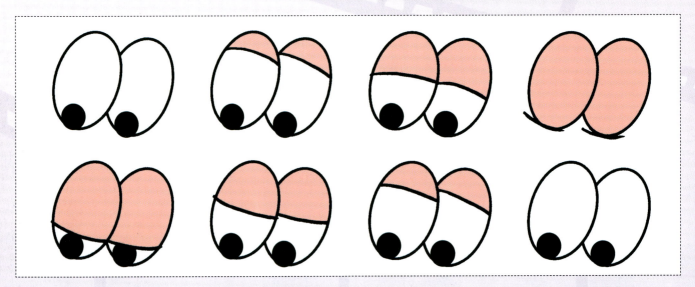

In the meantime, have a look at the next blink sequence in which the eye lashes are involved – rather like the tail of Harvey the dog in the previous pages, they trail after the action. There are no hard and fast rules about any of these cycles and many of them are named after the animator who first created them. This one, for instance, is very effective for the female eye and is called the Ken Harris blink!

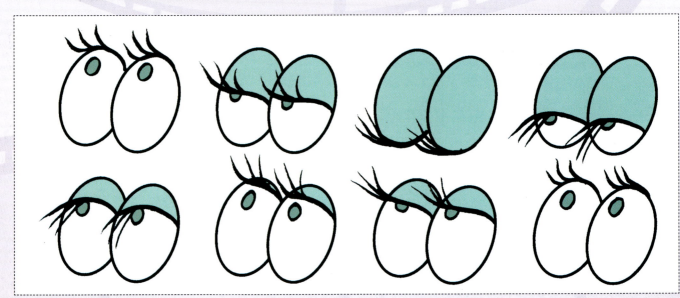

Now let's take a look at arms and hands, and a rule that's well worth taking note of.

The break

A key word in any animator's vocabulary is 'flow'. Without the conscious effort to make all movement flow, it becomes very mechanical and 'lifeless'! I'll take the example of Harvey hitting a table top with his fist. This is the way most of us would first expect to animate this action, but when played back it would turn Harvey into a stiff-actioned robot!

Try a little game for yourself here and act out the fist slam in extreme slow-motion. You might begin to see the secret of action flow as the hand and arm react together in a series of, what we call, breaks. Let me illustrate this more clearly in the short animation series below.

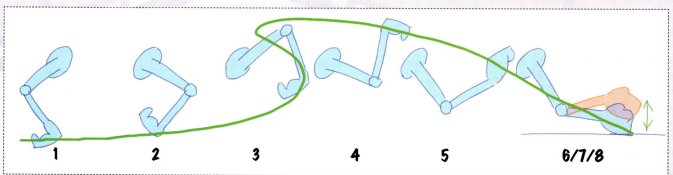

1 2 3 4 5 6/7/8

Can you see how the hand follows slightly behind the arm into the impact, then trails after the arm after impact? Notice also how the elbow bends unnaturally for a couple of frames. The eye cannot detect this but by including this action in your animation it will provide a kind of whiplash effect which will give much more flow to the action.

Breaking even works with the walk cycle. Here's a close-up of the arm movement during the walk. Notice the hand? Can you see how it trails after the arm in the forward swing from A until it flips direction at B and then trails the arm in the backward swing?

So now we're getting into the more subtle, yet necessary, principles of animation and the next, very important, basic principle is anticipation!

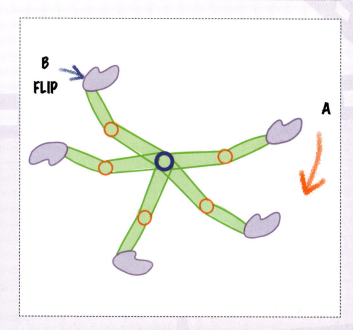

Anticipate!

Anticipation occurs when a character moves back slightly before starting an action. This always happens in real life. It is a way of gaining momentum to start the action! You can see this occurring on the athletics field. Watch the pole-vaulter rock back on his heels before starting his run, or the javelin thrower arching backwards before releasing the javelin. This is anticipation! Anticipation will make your action far more dramatic or even comedic. The exaggerated pose will hardy be noticed in the final animation but will make a world of difference in two ways. Firstly, it will subconsciously direct the eye of the viewer to the piece of action you wish them to see. If you have more than one character in frame at any one time then this is a vital ploy to help show the viewer what to look for next, especially when the action is fast. Secondly, the anticipation pose will add greatly to the smooth flow of that action. I need to show how this works with some key poses.

The first pose illustrated here is a 'take' (see page 70) This establishes the delight of our pirate at discovering the treasure.

Here, pose 2 is the anticipation before the grabbing of the money. But anticipation can determine the power of the action as well. The more powerful the action, the more extreme the anticipation pose.

In pose 3 we can cheat reality by making the chest react to the power of the pirate's thrusting hands. You can see how the chest squashes then stretches – just as the example of the bouncing ball on page 58.

In the final pose we need to show, by an extreme action, the sheer delight felt by the pirate at suddenly becoming very rich!

Anticipation, however, was the critical pose as it enabled the pirate to get his arms ready for the thrust, but, more importantly, allows the viewer to get ready for an imminent, fast action.

Here the movement is much more violent and quicker. The anticipation pose on 2 is more extreme to let the eye know how much power is going into the action. If this pose were not included, there is a good chance that the fast action would be missed altogether!

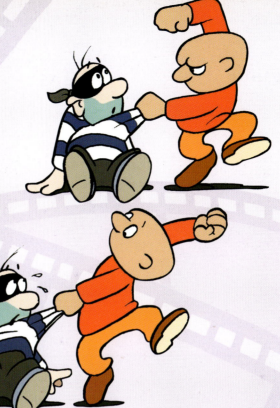

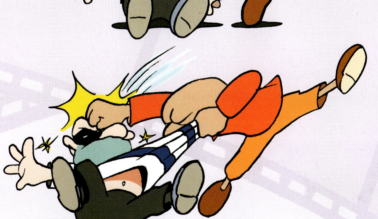

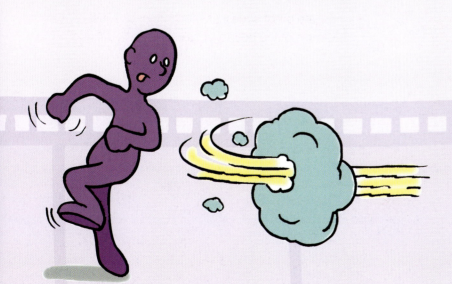

When the action is to be very fast, then we rely on the anticipation pose to tell us what is going to happen. The best example of this is the zip-off-screen action, which is usually accompanied with the sound effect of a rifle shot. You will recognize this pose by Harvey. Time is taken to show the anticipation and beginning of the move before the character disappears in a few speed lines of dry brushstrokes only to leave a slowly dispersing dust cloud.

Now, another action often used in comedy animation is connected to the anticipation pose and this is the take and double take. Let's see how this works.

The take and double take!

The take

Comedy cartoons, whether drawn or animated, are
always full of takes. A take occurs when your character
shows surprise and stares at another character or action.
Now this can be either quite subtle or completely over
the top! You will probably recognize this type of take,
which is still named after its originator, Tex Avery.

Each take is nearly always preceded by an anticipation
pose like this. Notice how the body distorts on 5 to give
that whiplash effect again.

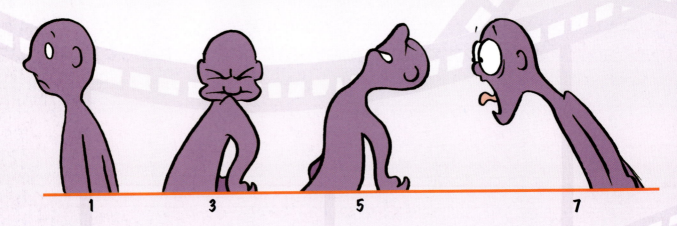

1 3 5 7

You can have lots of fun inventing
more and more extreme poses for
your takes as almost anything goes.
Your character can, literally, jump out
of its skin! Remember, this is the
world of animation and, armed with
your pencil, anything is possible.
Come on Harvey, give it your best
shot!

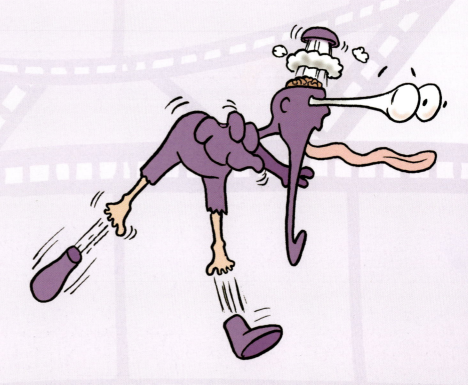

Sometimes your character might not
quite believe what they saw the first
time.

The double take

This action occurs when your character is completely stunned by what they have just seen. The sequence starts with a confused look (1), followed by a double shake of the head (2–10) just to clear the brain, and then a more amazed look in the last few frames. This is a form of anticipation before the final take. Notice the distortion on 9 which helps to carry the action through more smoothly on the extremes of 8 and 10 in which the head is pointing in opposite directions. The smoothness of this very quick action can also be enhanced by using dry brush marks, called blurring, as mentioned on page 62.

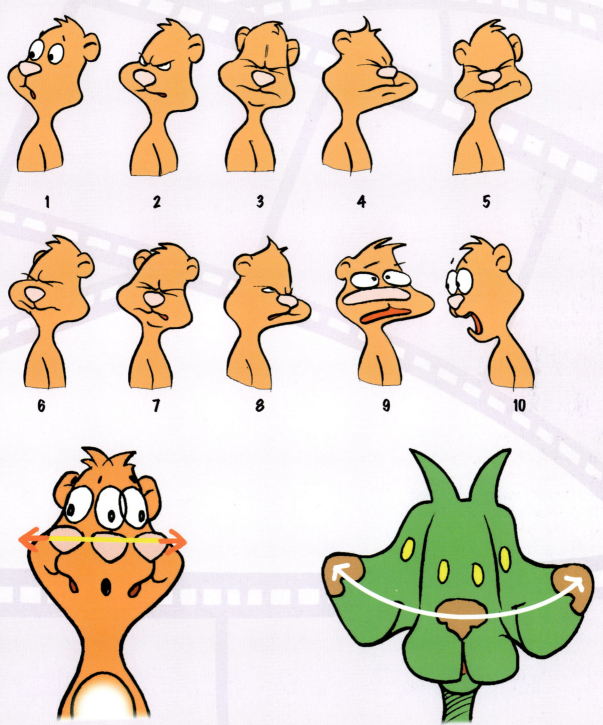

1 2 3 4 5

6 7 8 9 10

It's worth noting at this point how the head turns quickly. If you were to turn it on a straight horizontal line it would look unnatural, as if the head were rotating or spinning on top of the neck.

The head, in fact, dips a little as it turns from side to side, like this. Again, I would strongly recommend you try both of these head turns on a line test, just to see how important this rule is!

Accent and follow through

Whenever a body moves and then stops, it needs to settle. Your animation will look very unusual if the whole of your character comes to a dead halt on the last frame and is held there as if suddenly frozen in time and space. We get around this problem by using accents and follow through in a process called overlapping action.

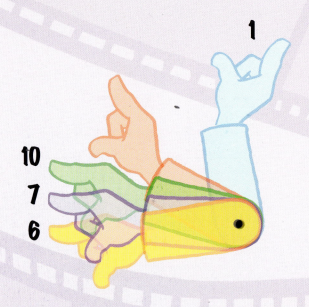

Accents

There can be soft and hard accents but I only want to deal at this stage with the hard accent. The best way of illustrating it is to show you a determined pointing of the hand. I am just showing you some key poses in this 10-frame action. The hand arcs down and dips slightly to 6 before returning to its final resting point at 10. This gives a more natural feel to the movement.

Follow through

Not all objects on a character will move in the same way. Different masses or weights mean different speeds. Coats, ties and dresses on a human character, or tails and ears on an animal will drag behind and follow through. Take this example of a girl's pigtails.

Can you see how, as the head moves forward, the pigtail is pulled behind? When the girl stops, the momentum keeps the pigtail moving forward and swinging back and forth until that momentum has been used up. Also notice the hair. This is what we call follow through.

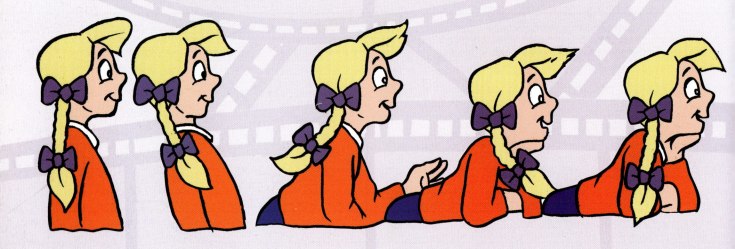

Overlapping action

I can best illustrate this by taking a look at a long-eared, long-tailed dog as he comes to a sudden stop. Here, in frame 2, the dog's front paws have come to a halt but the back legs only come in on frame 3. Then the weight of the body momentum has his torso pushed down in frame 4 before rising to a proper standing position in frame 6. But this isn't all. Notice the long ears and the tail performing the follow through. The ears can still be swinging after frame 6. Just as the girl's pigtails, on the opposite page, the dog's ears can keep moving for several frames after frame 6.

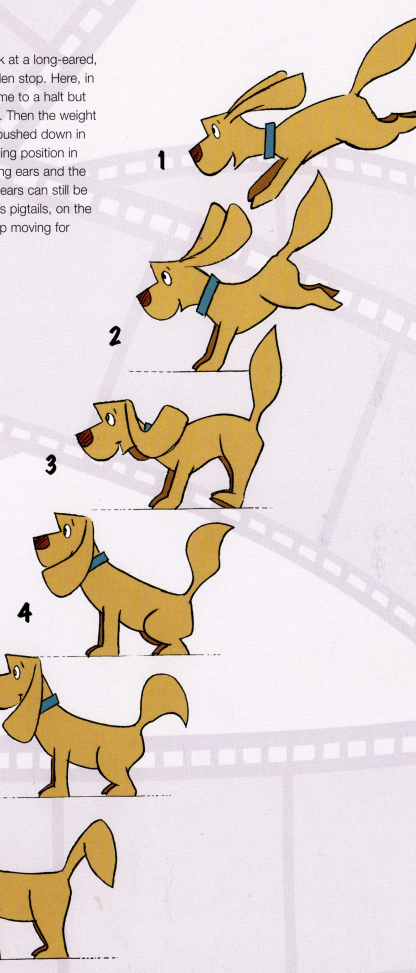

Flying

Bird flight can be rather complex but I'll try to show you some cycles in as simple a manner as possible. This is a standard repeat flying cycle and I want you to look at a few points. The power in the wing is on the downward stroke. Notice how the wing flattens out to give maximum push on this stroke, which raises the body of the bird slightly from the horizontal flight path. As the wings return upward, they fold to reduce drag and the body of the bird sinks slightly. Use a guide grid, as mentioned on page 59, to help you here.

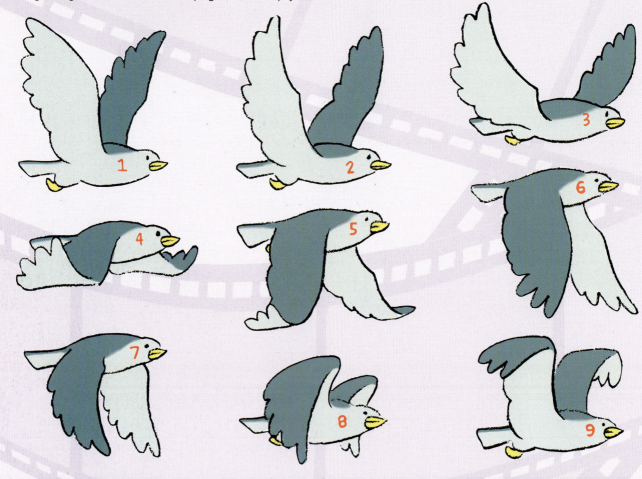

Size matters

The speed of the wing beat will depend on the size of the bird – or insect! A small bird such as a sparrow might beat its wings up to twelve times a second whilst a much larger bird would only beat its wings once every second or so. The example above is a beat of three-quarters of a second. A fly's wings can be shown as a simple two- or three-frame cycle, as can the butterfly's.

For the fly, you would use just one frame for each position. This would create the blurred effect of a very fast wing beat. In the case of the butterfly, you would shoot each position for, say, three frames at a time to give a much slower beat. The flight path for each of these insects is also important.

You can see how the fly darts and hovers in an erratic way whilst the butterfly's path is direct but a more exaggerated up and down movement than the first cycle shown opposite. Of course you can avoid animating the flying cycle altogether in your film if you use birds that glide or soar! Smaller birds like swifts or swallows and larger birds such as eagles and vultures spend a great deal of their time in the air soaring on the warm upward air currents called thermals. You could fall into the trap of just using the one drawing and moving it around the sky in swoops and dives. This will give you a very unrealistic looking bird and a very flat look to the scene.

Again, I stress the importance of three-dimensionality! Take a look at this flight path model and see how the character would have to be treated to give the scene dimension and interest. Obviously, if the flying birds are in the very far distance, you will be able to get away with a much simpler technique.

TIP

Don't forget!!.. The further away, the slower they move across the sky and… Line test, line test, line test!

Now I've shown you some of the basics of animation cycles I want to move on to what is, perhaps, the most important section of the whole animation process and this is TIMING!

TIMING

Timing is the secret of all good animation and that's why I'm devoting the next six pages to this topic. I've had to touch on timing on several occasions throughout the other sections but here I shall attempt to take you step by step through a small part of the basic theory of timing itself. Remember our simple rule of thumb: the slower the action, the more frames required. The faster the action, the fewer frames required.

It's all about... timing!

No matter what happens, a projector is going to be running at 24 frames a second and a TV camera needs 25 frames a second and this is what you have to work to as an animator. The strip down the side of the page is an example of one second of animation. Practice and experimentation will tell you what six frames, eight frames, 12 frames and 16 frames feels and looks like. Just as an actor needs to rehearse, you will need to go over an action in your head and work out the sequence and time needed for each section. Animation Directors do just this and then notate the action on a frame strip. Here is an example.

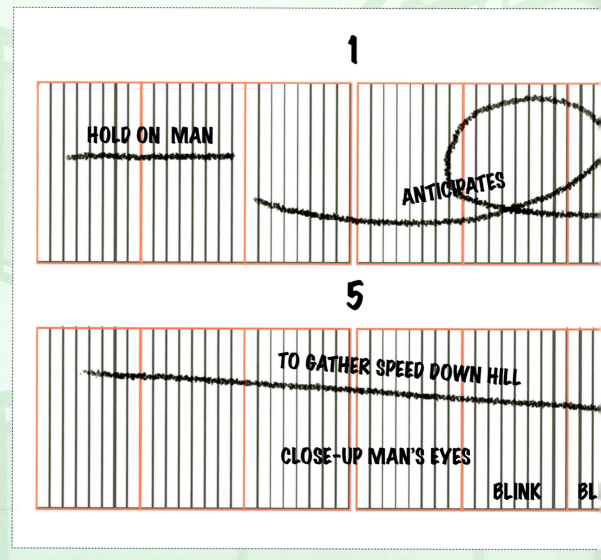

1

HOLD ON MAN

ANTICIPATES

5

TO GATHER SPEED DOWN HILL

CLOSE-UP MAN'S EYES

BLINK BL

See how each second is divided into 24 frames? These are then divided into 8-frame sections that help the eye when notating. The Director will play the action through in his or her mind and then write it down in this type of shorthand. It is then worked out in more precise detail on what is called a bar sheet. It's a lot like writing a musical score except, this is for action! The notation takes great skill and experience but is vital to enable each department to work together with accuracy. This will not be so necessary when you're working on your own but I would advise you to try some simplified version of this method that will suit you. It's so much easier to have a plan to keep referring to when producing each section or scene of animation.

TIP

You can make up your own frame strip in your computer, or simply draw one second on a sheet of paper then photocopy it as many times as you need!

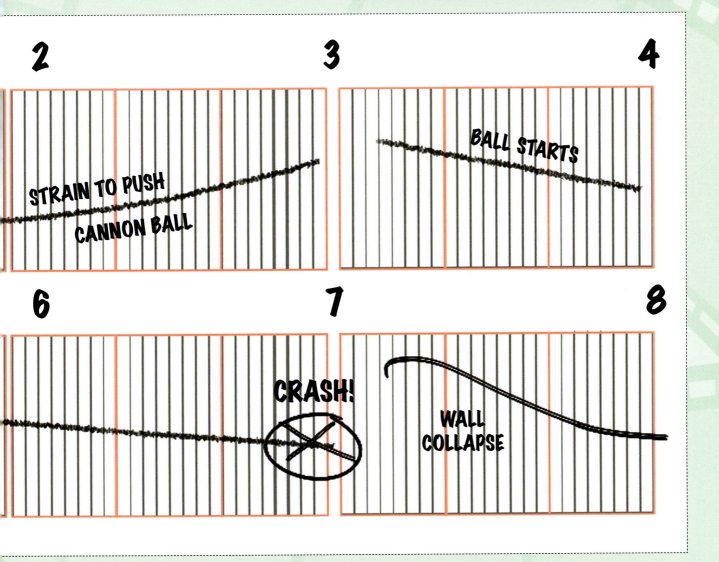

Now let me show you some basic ideas for the timing of motion and the forces that may affect that motion.

Gravity and weight!

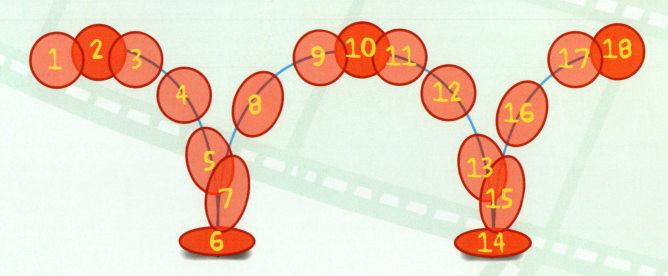

Gravity

I think all trainee animators must start with the bouncing ball. This is a deceptively simple piece of animation but if you have never tried animation before I recommend that you have a go at this exercise first. Just in this one piece you'll see the importance of speed change and the squash and stretch effects. Notice how gravity takes hold of the ball. It slows on the rise (more frames closer together) and speeds up on the fall (fewer frames further apart). When you animate any object you have to consider the effect of weight and gravity. No object, animate or inanimate, starts a move at the speed it travels. It has to gain momentum, that is to say the weight of the object needs to be overcome by the force of the movement before full speed can be achieved. Exactly the same effect occurs when stopping a movement. It has to be slowed down to a halt!

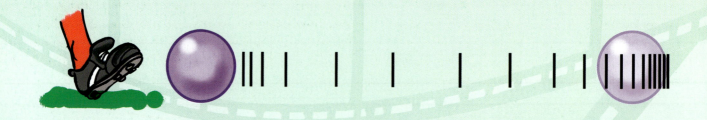

Weight

Let's take a look at another two spheres. This time one will be very heavy and one very light indeed. One is a balloon and the other a cannon ball. How will you have to animate the action of movement to show the difference of weight? To start with, the cannon ball will need a lot of force and more time to get it started but once rolling it will move at a regular pace and ...

... will need a great deal of effort to stop it!

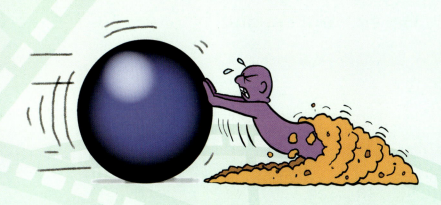

The much lighter balloon, on the other hand, will need very little effort to move it but it is so light that moving through air is like you swimming through treacle! The air resistance soon slows it down.

An interesting addition to the balloon animation is that there will be a touch of 'follow through' as the balloon swings around its centre of gravity slightly after coming to a halt before gravity takes over and it sinks slowly to the ground.

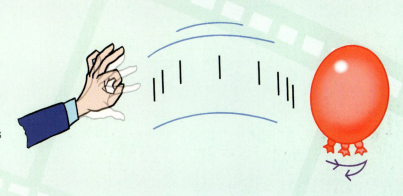

These two extreme examples of the same shape show clearly how the timing and spacing of drawings alone can determine the impression you give to the weight of an object. A very old stage act has a circus weightlifter struggling to raise a pair of large heavy balls above his head. After successfully completing the task and taking a bow, a small child or old lady comes on, picks up the weights without effort and takes them off stage, to the amusement of the audience. The weights, of course, are just balloons or polystyrene made to look like large iron balls. The impression of weight was given by the effort and timing of the weightlifter.

Timing and fast action

Fast action is always preferred in comedy animation to give the film pace and excitement. As you will realize by now, this also means fewer drawings and, in very fast action, a big gap between one pose and the next. If this were viewed on live-action film, a blur of the moving object would be seen to trail after it. This helps the eye to imagine the 'travel' from one position to the next. In animation we have to invent methods of showing this transition and also give the viewer's eye plenty of warning of the fast action to come with the anticipation before the action. Let's take a look at Harvey throwing a custard pie at some unfortunate opponent!

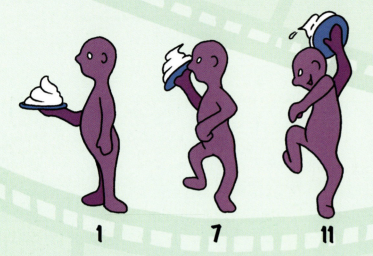

1 7 11

The throw is going to be very quick indeed and we need the viewer to be aware of what is about to happen. I have numbered the poses in these examples to give you an idea of the timing. Harvey's draw back is slow and deliberate. From the hold on 1 we need another 10 frames to show the anticipation at 11.

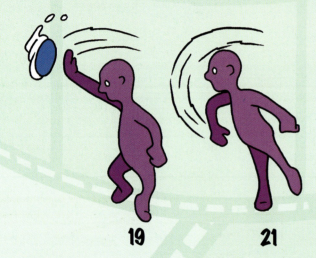

19 21

The throw will be much faster. There is only one more drawing between the next examples so we could do with some continuity. See how I've included speed lines? I could have used dry brush or ghost images. Let me show you more of these in a moment but first...

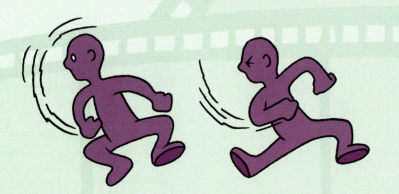

25 27

Just let's finish this sequence with an exaggerated follow through to show just how much energy has been expended. The slowing down and stopping of the action can also add to a more dynamic feel.

Dry brush and speed line effects have to be created so quickly that they give an impression and are gone before they are hardly noticed. A good rule of thumb is that the human eye and brain cannot understand any action less than three frames in duration. A classic case used in animation is when a character has to vanish quickly off screen. I mentioned this briefly on page 69. Here's Harvey again to demonstrate.

Harvey anticipates in a very exaggerated pose in the opposite direction to that in which he is to move. He would exit in very few frames. You might want to stretch him here. The interesting thing is that now the dry brushstrokes will animate in the opposite direction to that of the exit. Otherwise they'll simply look like ribbons trailing after the character.

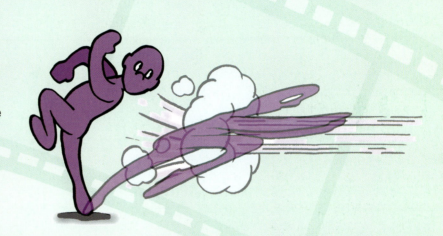

Here is another example often used in comics. Imagine we have a cannon ball that has just been fired from a pirate ship. The ghost images of the ball (A) should quickly disappear where they're formed whilst the speed lines (B) can move slightly in the opposite direction to the flight of the ball.

If you want to know more about timing, there are some excellent books published on the subject.

It's time to look at that other very important department of animation: the Special Effects!

SPECIAL EFFECTS

We tend nowadays to think of special effects as being the way in which film makers can show off and pull people into the cinema to shout 'How did they do that?' However, the truth is that special effects, or SFXs as they are known, are the animation of anything and everything that is not a living creature or which has to move in the background. In the professional world of animation you'll find that animators will specialize entirely in this field. So, there are two types of animator: the special effects animators and the character animators. You, on the other hand, will have to tackle both jobs! In the following pages I want to show you some of the most common tasks you are liable to come across.

Waves and water

Waves

The wave motion is used very often in animation. This is another cycle that once drawn can be repeated over and over in a scene. You might see this effect in a waterfall or smoke rising from a fire or chimney perhaps. I think the easiest example to illustrate is of wind on a flag. If you can imagine the flat sheet of the flag to be formed into hills and valleys which travel along it in the direction of the wind we have a result that looks like this.

See how the hills (marked with an **X**) and the valleys (marked with a **Y**) travel along the sheet and can be repeated. A tip here would be to introduce slight variations occasionally to stop the action looking too mechanical. Also, one cycle should last one second or more. Remember, the slower the action you need, the more in between drawings required! You'll see this action used again with the waterfall.

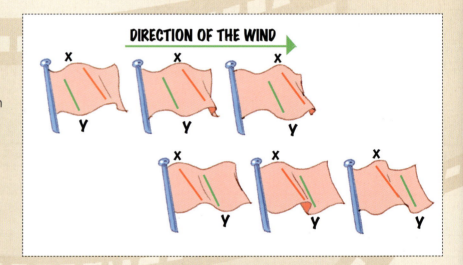

The splash

This effect needs to be tested before attempting to put it in a film but can be fun to draw. The amount of splash will depend on what has been dropped into the water. A drop of water will only cause a 'ploop' whereas a rock will cause a cascade of water. Each drop that is pushed upwards has to follow its own curve back down to the surface of the water but it's not necessary to draw every single droplet. Here's how we do it. Notice the central spout that grows and then falls back into the middle of the splash. The drops can then be 'vanished' into the ripples as they hit the water.

The ripple

Under the splash you will get a ripple cycle. The ripples are, again, a cycle of drawings to be repeated for the duration of the shot. Use a frame of concentric circles such as this for a guide.

Here we have a typical ripple pattern superimposed over the ring guide. You can see how the motion of the travelling ripples radiates outwards from the centre and slowly diminishes in size until it disappears. In real life the ripples would travel much further but this would mean a massive amount of drawing for a simple effect and, in fact, the eye accepts this cartoon form very readily.

The waterfall

To finish this section I want to show you a simplified version of the waterfall cycle. The waterfall is very often used in films in any situations where running water is seen. What is interesting about this example is that it contains examples of splash, ripple and wave effects.

What I want you to notice here is that, in the falling water, the same shape should not travel all the way to the bottom. This would make the water appear as some sort of solid conveyor belt. However, if you plan it properly you can match up shapes after only four or six drawings. A tip here is to animate each effect separately as they will all be reacting in a different time scale. I've shown each in a different colour to make things clearer to see. These cycles can then all be brought together for the final effect.

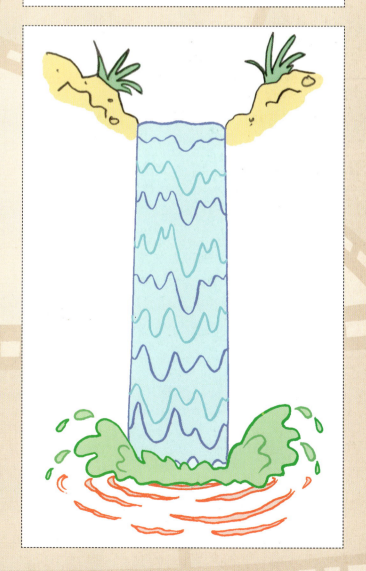

Rain and snow

Rain

Animating rain and snow is a fairly easy task. The movement will be in regular graduations across the frame. Once completed it can go into your library of effects and be used over and over again. However, there are various pitfalls you should avoid. Let's look at the rain cycle first. The first problem that may arise is that your animation could look very mechanical if you tracked the rain in parallel lines like this.

Try to vary the line directions slightly to give a more natural look to your animation. Notice how the rain, pushed by the wind, rarely falls vertically. Here you see two examples: **A**, rain in the foreground (i.e. in front of your character) and **B** (below), rain in the background (i.e. behind your character).

This will give depth to your shot. Remember that whatever moves in the foreground is bigger and faster than that in the background! The foreground rain could pass in about six frames whilst the background rain would be slower and slower the further away it gets. One tip I have for you is to make the cycle at least 24 frames long, otherwise you will slip back into that mechanical feel again when the eye recognizes the cycle too easily.

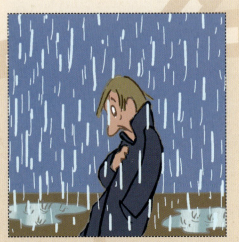

Mood

The weather effects can influence the mood of your shot a great deal. If you want to enhance the feeling of misery, then have the rain falling slowly and vertically. However, if you want to show battle and determination you can have the rain coming down much faster and at a steeper angle.

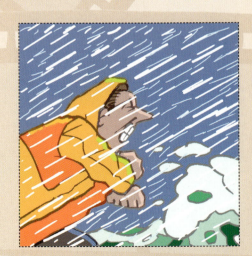

Snow

This is a much gentler fall. Snow is very light and therefore much more influenced by air currents. The track of a snowflake is a wavy line. Again, avoid the regular spacing and have the tracks crossing over each other like this. Notice how in **A** the flakes are larger and move more quickly than those in **B** (below). They will take about two seconds on double exposure to get from the top to the bottom of the frame.

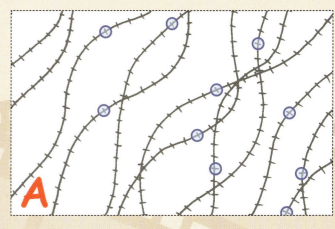

The flakes in **B** are further away and therefore smaller and slower. You might find you need more than two layers here to give a convincing effect. I would also advise here that the snow cycle lasts longer than the two seconds it takes for the flake to fall otherwise the eye will detect the repetition.

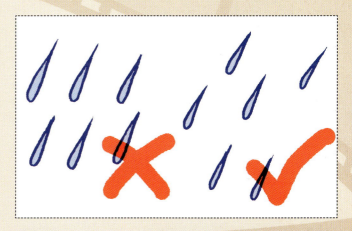

Make sure you vary the position of each raindrop or snowflake so that they're not all coming down line-abreast. The example on the right will create a much more realistic effect.

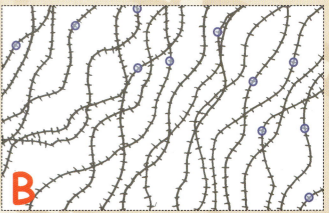

Notice here there are three layers of snow cycle in the fore-, middle and backgrounds. See how the background cycle (in white) can 'disappear' as it gets to ground level.

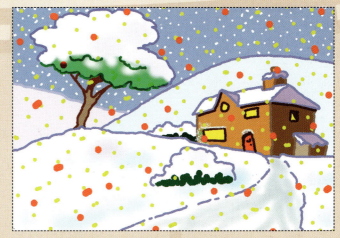

Smoke and flame

Smoke

There are a variety of types of smoke but I want to concentrate on the wisp and the puff! Smoke acts in a similar way to the snow cycle. The smoke is even lighter and therefore more influenced by air flow. Let's first look at a simplified drawing of wispy smoke. This is the type you would see as rising steam or smoke from a chimney. It is a lazy movement and will require 32 or more frames.

Here I have put in guidelines to show the steady, upward movement. Your aim is to animate the curves of the smoke from **A1** > **A2** > **A3** and so on. The same applies for **B1**, etc. Notice that at the top the wisp begins to break and disappear. Also, note that as the smoke cools, the rise slows down and the lines are closer together.

The puff of smoke can be treated in a similar way. This is the type of smoke that comes from a fire or an old steam train. Again the animation is from **A1** > **A2** > **A3**, etc. Notice that the plume is snaked in a similar way to that of the wisp and that the puffs break from a solid column into individual units that gradually get smaller until they disappear.

Another cycle you might often want to use is the type that comes from a car exhaust. Here there is a combination of puffs and rings. This helps to stop the cycle looking too mechanical. Notice the short distance before the smoke diminishes and disappears or 'pops' off!

Finally, there is the billowing cloud. Depending on the speed, this can work for a gentle beginning of a dream sequence or the faster impending doom of creeping fog or an avalanche! Here I've put all the frames together to show you how the cloud would expand. Can you see how each curve has a definite route? Notice also how you have to introduce more shapes as the cloud gets larger, otherwise it won't billow!

The flame

Now I'm going to show you a classic flame cycle that you'll see in many animation films. These shapes are used as they are easier to animate. The movement of the flame is driven by two main forces: the air flow and the heat.

As the cold air is sucked in at the base it is warmed and rises with the flame. The base of the fire is the hottest and the flames cool as they rise. This means that the movement slows down as we get to the top of the fire. Notice also that the shape is roughly that of a cone and that elements break off to get smaller and disappear as with the smoke puffs.

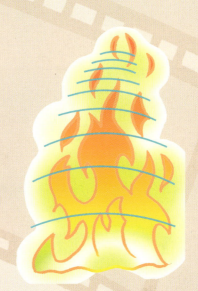

Now let's look at the whole cycle.

Flames flicker so there is no great need to follow each element carefully upward as you can see. What is important, however, is to show the movement of the eddies – I've marked them here with dots. An eddy is the space caused by the cold air being drawn into the hot flame. Notice how they flow up through the cycle.

1 2 3 4

5 6 7 8

YOUR OWN PROJECTS

I hope this book will be of great help to you and something you can keep for a long time as a useful reference tool in your future journeys into animated film. I don't want you to be too awed by all that's contained within these pages. Remember, the secret is to enjoy your projects and not see them as mountains to climb. Start small. Only ever tackle that which is attainable at that moment. Bask in the thrill of achievement you get when you see your characters come alive for the first time and sense the excitement you will have in trying something new and a little more ambitious for the next project!

Know your equipment

There is absolutely no sense in starting a project until you know how to use your camera, computer and animation programme. I would advise you to work on these first. Most animation programmes for the computer will have exercises built into their 'Read-Me' files. Try these first to see exactly what you can and can't do in the programme.

Timing

Get used to the timing and distances of movement needed. You can begin with a simple exercise of moving inanimate objects around a table top.

Seeing how fast or slowly objects move at 24/18/16/12 or six frames a second will give you a good idea of how to treat your drawn characters. Also remember that most animation today is shot on doubles, that is to say two exposures for every drawing so you will need only 12 frames per second, not 24. However, if your action is very slow you will need some moves to be shot singly. Only experience can teach you this so don't be afraid to experiment first.

Planning

I stressed earlier the importance of planning your project. There is a very good reason why all the stages I've mentioned are involved in the production of an animation film. Without any one of them you will only, at best, cause yourself confusion and, at worst, find that you have lost valuable drawings or footage.

File, file, file!

You must keep each scene in a clearly marked folder and know, at the end of each day where they all are and keep checking to see that they contain all elements. When drawing or shooting a scene, plan the layout of your working area so that piles of paper are in order and do not get mixed up.

Script

Start with a simple scenario, perhaps just one event which might take only a minute to tell. You can develop this into a full story as your confidence and skills grow.

Storyboard

This is your chance to decide exactly how the scene will be shot and which will be the most exciting angles. Do NOT try to change your ideas in the middle of a shoot.

Design

Make sure you know exactly what your background and props are and where they belong.

Layout

Have a planning sheet in each scene folder which tells you how each scene is to be shot and what is needed. This piece of information is vital when you have a dozen or more scenes to contend with.

Now let's take a look at some of the ways in which you can animate at home.

Cut-outs and claymation

So far in this book I have been describing some of the basic rules of animation and relating them to two-dimensionally drawn cartoons. There are two other methods you can try at home using the same basic techniques.

Cut-outs

This is a method that you might very well have come across already at school or on courses. Several very successful children's animation series have been produced using this method. The advantage of cut-outs is that, once planned and constructed, a complete film can be made relatively quickly and cheaply.

Here you can see a version of Harvey with his arms, legs and head separated from his body. These would be drawn onto card and coloured up.

The various parts can then be joined together with a split pin and the character moved under the camera in the same way as you would with the drawings. It's up to you how many joints you make. The more joints, the better the animation.

You can produce some very effective results, very quickly, with little animation. Look at these two examples for instance. The rocket is simply a cut-out moved across the background with, perhaps, a coloured cellophane effect for the flames. The car is using the same background pan as explained on page 53 with the alien spacecraft. An occasional blink of the driver's eyes would also add to the overall effect.

Claymation

This form of animation has become very popular. The work of Aardman Animation has seen this art form used in full-length feature film format. This is the truly three-dimensional genre of animation, in which all characters, props and sets are in model form. For those who enjoy model making, this is the most enjoyable way to create your own animated film. Again, all the basic rules apply apart from your method of animation. You will have to use the 'straight ahead method'. This means moving your model frame by frame in order: 1, 2, 3, 4, etc. You cannot go back and in between!

A tip would be to film yourself or a friend acting out the action. This can be viewed frame by frame on the computer to show you how much to move the character each time. As you can see here, Harvey can be made in plasticine, which is easily moved into the various poses needed. You will have two methods of building your models here. The basic rule of thumb is that anything that moves is built in plasticine and anything that does not can be built in any material that is suitable. There are several points to watch out for, however.

• You'll need a large table top or flat surface to build your set on. Use one that can house the model permanently until the film is finished. You can't afford to keep packing it away and rebuilding each day!

• Remember that a three-dimensional set has to be lit in a three-dimentional manner. Check your lighting through the camera lens until you're absolutely satisfied with the results. Too much shadow or light can ruin the final effect.

• Try to avoid showing a full-length character walking. There are many complications in keeping a plasticine model steady and upright whilst animating a walk cycle.

• It is also important that you can turn your lights off after each shoot and whilst you are remodelling. It doesn't take too much imagination to realize what happens to overheated plasticine!

Special effects can be fun to work out. Smoke can be created using cotton wool. Running water can be achieved by using strips of cellophane or any other soft, transparent film. Again, I would advise you to look at films made in this way to see if you can spot how things were done.

I hope this book has been packed with ideas for you and you are now raring to get started. The rest is up to YOU! Have fun and... enjoy!

GLOSSARY

A selection of terms used within the animation industry

Accent When a direct action, such as a finger point or a punch carries through slightly and returns to the stopping position to give a more natural feel to the power (see page 72).

Acme peg bar Acme is the standard used globally. The peg bar is a strip of metal holding three pegs: two oblong and one circular, which hold each sheet in perfect registration to the next for drawing or filming.

Animation disc A back-lit circular Perspex or glass sheet in the centre of an animator's board which can be freely rotated to ease the control of drawing accurate lines and shapes (see page 14).

Antic The shortened version of 'anticipation' or the pose immediately preceding a fast action (see page 68).

Bar sheet A director's hand-written guide to the timing of action and effects within a scene (see pages 76–77).

BG Short for 'background' or the scenery behind the animation (see pages 50–55).

Bible This is a reference folder, which is a guide, containing all the information needed to be able to reproduce accurate drawings and colourings consistently (see pages 36–37).

Breaking The art of making hands, feet and limbs move separately from each other at the joints to give a more natural flow to the action (see page 67).

Camera rig The sturdy metal frame that holds the camera and controls its every move without shaking (see page 16).

Cell A sheet of celluloid on which the animation is drawn and painted. Now more commonly seen as collectors' items since nearly all work is carried out digitally on computers.

Colour card Often shortened to CC. This is a plain coloured background often used in close-ups or extreme close-ups.

Concepts Usually drawings or paintings made at the planning stage to give ideas of characters, scenes or colours that could be used for the final production.

Cut This change from one scene or shot to another is immediate without any fade or mix effects.

Cycle A series of drawings of a complete action that can be repeated indefinitely. Most commonly used in the walk, run and fly cycles or in special effects.

Daylight bulb A specially blue-tinted light bulb that gives off a white light similar to daylight. This is essential equipment for judging the true value of colours.

Depth of field The art of making a two-dimensional drawing appear to be three-dimensional with the use of size, perspective and colour.

Exit frame left/right The term used to describe how a character enters or leaves the frame.

Exposure or dope sheet A chart to show the cameraman and animators what to do frame by frame. This is especially necessary for forming the mouth shapes for lip-sync.

Fade to black This effect is sometimes used at the end of a scene over six frames or more when the image progressively mixes to a totally black frame.

Field The dimensions of an area in which an artist will work or a cameraman will shoot.

Flip There are two common uses of this word. To flip an image so that it faces the opposite way to that of the original, or the action of an animator when checking their work to see if the animation is correctly drawn (see page 57).

Follow through The reaction of appendages such as tails, hair or floppy ears which carry on moving after a body has stopped (see page 72).

Forced perspective The bending of perspective in a background pan to imitate the changes seen when a live-action camera pans (see page 52).

Frame Each individual picture or composition of any animation. There are 24 frames in one second of film.

Framing Placing the characters and elements in the background into a composition that is pleasing to the eye (see pages 46–49).

FX's Short for 'effects'. These can be sounds or special effects such as weather or explosions, etc.

Graticule Also known as a field guide. A transparent graph/grid of a given field which is placed under artwork, allowing the layout artist to plan out a frame and give directions for camera moves (see diagram below).

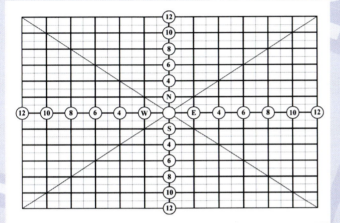

In between The process carried out by the assistant animator for drawing the positions 'in between' the poses created by the senior animator for a given character (see page 56).

Keys These are the poses drawn by the senior animator, with timings, to show how an action will take place. They are sometimes referred to as 'extreme keys' (see page 56).

Layers This term originally comes from the method of using several layers of cells, one on top of the other, in one shot to give the impression of three dimensions. The same effect is now achieved on the computer (see page 55).

Layout The technical planning of a scene which shows visually how the scene is to be constructed from backgrounds, to animation and camera moves.

Lip sync Mouth, tongue and teeth shapes are drawn to synchronize with the actors' dialogue.

Mix This effect occurs between two scenes when one progressively fades out as the new scene fades in.

Model sheet A reference sheet kept in the bible to show how a character is constructed and how they would pose (see pages 36–37).

Morph The term is short for morphing or the action of changing one shape into another by gradual animation.

A good example would be the witch's wicked spell that changes the prince into a frog!

Overlapping action The art of making various parts of a character move at different speeds (such as in follow through) to give a more natural look to that character (see page 73).

Pan The camera moves across the background either laterally or diagonally. You would do this when following a subject for example.

Passing position The frame of a walk or run cycle where the hands and feet are passing each other.

Platen A clean glass plate which is laid over artwork to keep it perfectly flat for shooting under the camera.

Props Any objects that will be used by an animated character and which must be kept separate from the background (see pages 42–43).

Punched Paper Animation paper that has already had holes cut into it to hold it securely on an Acme peg bar.

Reg or registration. This is usually a line drawn in red on a background by the layout artist to indicate where a piece of animation has to register exactly with a part of the background, e.g. a rabbit jumping behind a rock (see illustration below).

Repeat pan When two or more pan backgrounds are joined end to end to form a continuous loop. This, for instance, is often used for vehicles travelling along a road (see page 54).

Roughs Drawings, usually completed with a blue pencil, that show the loose construction of a piece of animation. These would be 'cleaned-up' at a later stage.